D1254721

SPITFIRE

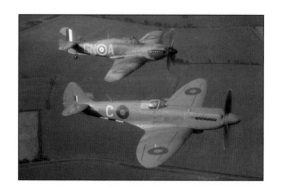

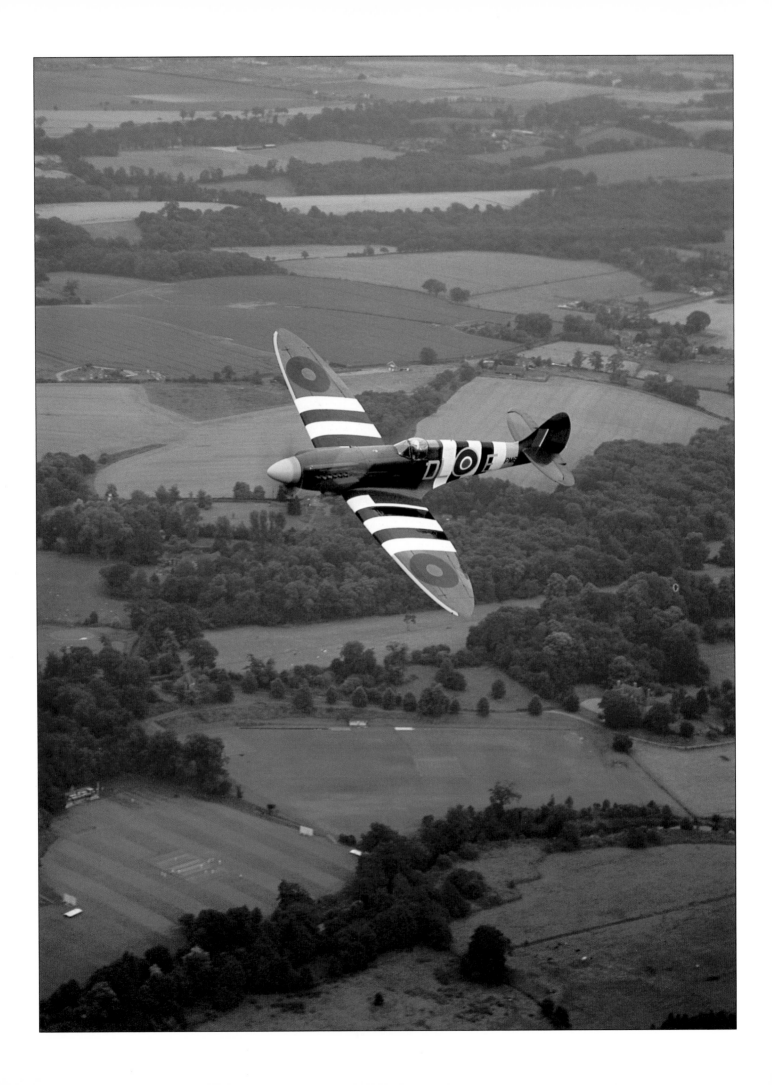

SPITFIRE

Jeremy Flack

This edition published in 1996 by the
Promotional Reprint Company Ltd,
Kiln House,
210 New Kings Road,
London SW6 4NZ for
Booksales in New York, Chapters in Canada and Chris Beckett Ltd in New Zealand

ISBN 1 85648 329 0

Printed and bound in China

COVER: A gathering of Spitfires over the Arizona desert.

PAGE 2: The RAF's Battle of Britain Memorial Flight Spitfire PR Mk XIX, PM631 swoops low over the English countryside. The black and white stripes were painted just prior to the D-Day landings as an easy aid to recognition of Allied aircraft to reduce the chances of their being shot at by Allied troops or aircraft in error.

OPPOSITE: HF Mk IXe MJ730 breaks formation and displays the classic Spitfire wing shape - R J Mitchell's supreme combination of function and beauty.

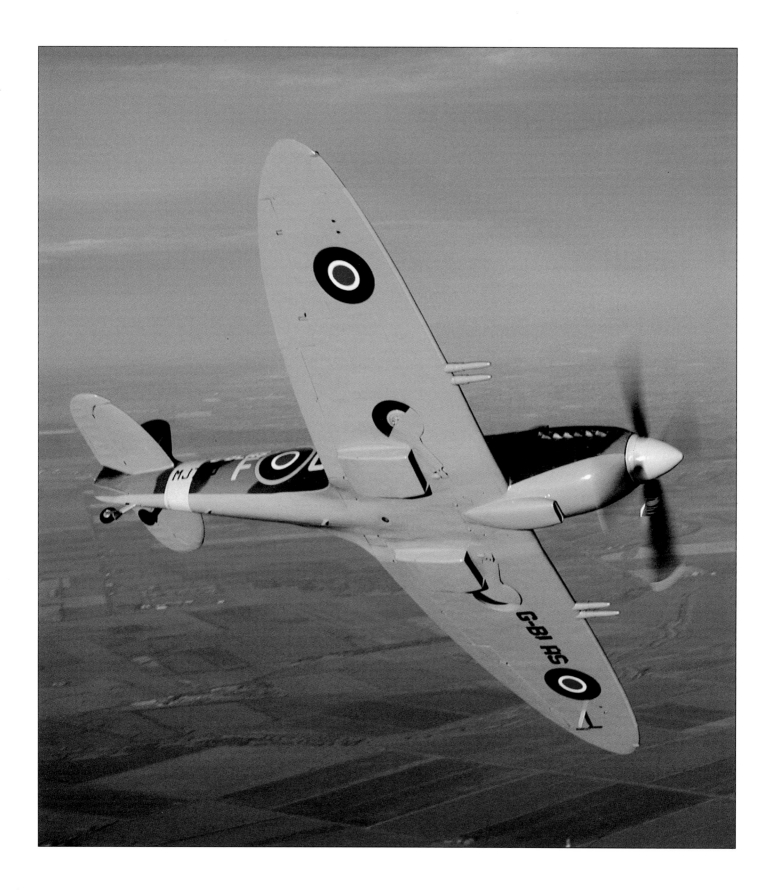

CONTENTS

INTRODUCTION

The Supermarine Spitfire is the most famous of all British fighters. Designed by Reginald J Mitchell at a time when all the serving RAF fighter aircraft were canvas-covered biplanes, the prototype was funded by the Air Ministry for just £10,000. It first flew on 5 March 1936 at Eastleigh, now Southampton Airport. The first Spitfire deliveries to the Royal Air Force started in 1938 to No 19 Squadron at RAF Duxford. Due to its simpler construction, larger initial orders were placed for the Hurricane and when war broke out the Spitfire equipped just 10 squadrons. Later, when the Battle of Britain commenced in July 1940, the number of Spitfire squadrons had only increased to 19 while the Hurricane was equipping 38. Despite this imbalance, it was the Spitfire that caught the imagination of the public and also raised the main fear in the enemy. During the Battle of Britain (10 July 1940 until 31 October 1940) some 1,733 Luftwaffe aircraft were destroyed plus a further 643 damaged as against 915 RAF aircraft lost by Fighter Command of which over 350 were Spitfires.

The Spitfire remained in production throughout World War 2 and on into the postwar period through some 40 types with developments raising its maximum speed from the 349mph (562km/h) of the Mk I to 460mph (740km/h) of later models, the fastest being the PRXIX. As well as being fitted with increasingly heavier firepower - guns and cannons - later Spitfire variants could be fitted with drop tanks which extended their range; others were capable of carrying bombs or rockets for ground attack. When production was completed a total of 20,351 aircraft had been built, plus 2,622 of a strengthened naval variant named the Seafire for use from aircraft carriers.

Despite the number built by the early 1960s just a handful of Spitfires were still capable of flight. The making of the film *The Battle of Britain* by United Artists was probably the greatest single factor in turning the tide on the almost total extinction of airworthy Spitfires. During the preparations for the actual filming, the world was scoured for all potential Spitfires. Those that were capable of looking like an operational aircraft were hired. Some 27 Spitfires were used in the filming while a number of others were gathered to provide spares for those capable of flying. Some of the Spitfires used had been gradually deteriorating and were given some needy attention: some were made capable of taxying, while a number were brought back to airworthy condition. In addition to Spitfires there were Hurricanes, Messerschmitt Bf109s and Heinkel He111s. Most of the German contingent were Merlin-powered examples that were borrowed or bought from the Spanish Air Force. For some of the distant flying shots the Hispano Buchons (licence-built Bf109s) were appropriately painted and flown as Spitfires. Once the filming was completed and the borrowed aircraft had been returned (19 of them had been loaned from the RAF) those that had been purchased by the film company were put up for sale.

Thanks to massive investment by their owners Spitfires can now be seen flying in greater numbers than existed a few decades ago. Currently the number of airworthy Spitfires is reaching 50 throughout the world with the greatest number, naturally, in the UK. This number is steadily increasing and will continue to do so well into the future. The reason for this is the large number of dedicated enthusiastic owners who have acquired various components over the years ranging from a few parts of twisted metal through to almost complete airframes. Depending on a number of factors, the restoration to airworthiness can take anything from a couple of years to a lifetime.

For those with sufficient resources, the task may be relatively short when given to one of a number of highly qualified aircraft restoration companies. A number of warbird collectors has also developed 'in house' engineering facilities which have developed the necessary restoration

skills. A smaller number of restoration projects are undertaken by individuals or small groups at a slower pace but with a high standard of workmanship.

Restoration of a substantially complete Spitfire involves stripping the aircraft back to components to check individual items for fatigue, corrosion or any other forms of damage. The rivets used in wartime construction were made from magnesium alloy which, due to the anticipated short life of a Spitfire, was not considered a problem. However, the modern restorer will find that most of these rivets have corroded over the years and each will require drilling out and replacement. Some of the components will require x-ray checks to give full assurance of the integrity of load-bearing items such as spars. For those with incomplete airframes, there will be the lengthy task of trying to locate the missing or damaged parts in order to replace them with manufactured new items. While Spitfire parts were built in their thousands during the war and were therefore relatively cheap, very few airframe spares exist today. To build one-off parts can be an extremely expensive option. Even parts that are built by specialist manufacturers do not have lengthy production runs and can therefore still be expensive. Once the components have been checked reassembly can commence in specially constructed jigs.

The cost of restoring a Spitfire may be in the region of £500,000. However, an aircraft with a documented operational record and credited with destroying enemy aircraft can now sell for close to £1 million - a far cry from the original £10,000 paid by the Air Ministry for the prototype.

The increasing interest in warbirds has seen a growth in the number of specialist airshows in Europe and the USA - and where there are airshows there's usually a Spitfire, even in the USA where, understandably, the P-51 is the most popular fighter. The Royal Air Force continues to fly a few Spitfires with the BBMF as a memorial to those who gave their lives during World War 2. One of these aircraft is a Spitfire Mk II that actually took part in the Battle of Britain.

Five Spitfires attended the huge Oshkosh airshow in 1995, while Spitfire pilot Chris Woods spent considerable effort in arranging a Spitfire gathering at Scottsdale Airport near Phoenix, Arizona. Although only six of the Spitfires finally made the event, this was a first for the USA and with the support and interest generated should produce an even greater number for future events. The 1995 Scottsdale airshow is featured in the Eagle Squadron chapter together with the initial meet at Carefree a couple of days beforehand. The sight of the Spitfires landing with the giant saguaro cacti is a little different to the more familiar European environment!

In the UK, the Imperial War Museum airfield at Duxford remains the mecca for many warbird enthusiasts. The Spitfire is well represented at the location where its operational flying commenced nearly 50 years ago. Spitfires of the OFMC and TFC feature in all the Duxford airshows and usually attract a further selection of visiting examples.

If you would like to see any of the Spitfires featured in this book, a listing containing details of aircraft operators with facilities for visitors is given at the back of the book together with major warbird airshow operators. They will be happy to provide you with details of when and where these aircraft can be seen.

Finally I would like to thank the various owners and pilots of the Spitfires featured and airshow organisers for their assistance and co-operation in helping me to get the material to put this book together.

RESTORATION

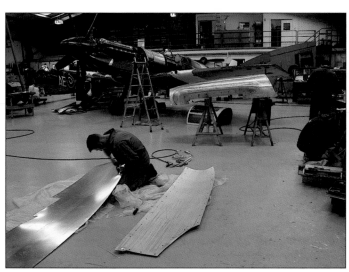

1 Aircraft restoration is an expensive operation running into hundreds of thousands of pounds. It will require a large amount of stripping and checking with vital load bearing items subjected to X-Ray inspection for any sign of possible fatigue problems. Magnesium alloy rivets were extensively used on Spitfires and they corrode over the years. They have to be drilled out and replaced - quite a job when there are 8-10,000 of them. The skin panels require a detailed check for damage.

2 How an aircraft has spent its last 50 odd years will have a bearing on the amount of new metal that will need to be used during the restoration. From museum piece to wartime wreck, each individual Spitfire will have its own set of problems. Some damage can look superficial initially but many internal parts can be extremely complicated and require many hours of work to replicate - and even replacement skin panels can have a complex shape.

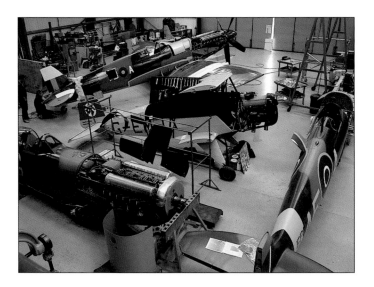

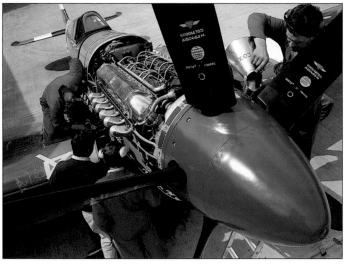

3 The scene inside the workshops at Historic Flying will usually see a number of Spitfires in various stages of restoration. To the right is TFC Mk V EP120, which has since flown. The Mk XVI, restored RW382 (left), is dismantled and awaits shipping to the USA. Upper left is SM832 which has also flown. Only just visible in the top left is a jig containing the bare fuselage structure of Mk Vb BM597 for the Historic Collection of Jersey.

4 TFC Mk XIV SM832 is shown here as it approaches the final stages of restoration. This is the moment of truth for all concerned. The engine and virtually all equipment will have been fitted. Most of the panels are in place except for the cowlings and wing fillet. Final adjustments are made, the glycol level is checked and topped up prior to the first engine run. It is at this stage that so many intricate details and problems could start to rear their ugly heads.

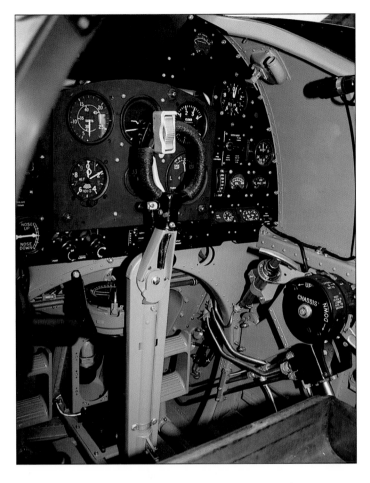

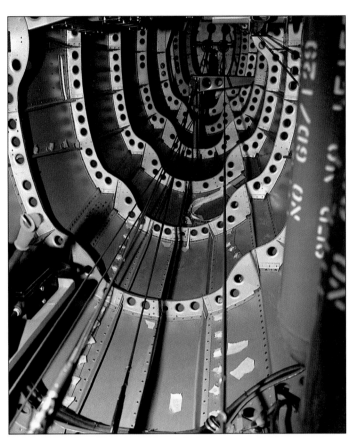

5 The cockpit of EP120 has been fully restored by Historic Flying according to the customer's requirement - in this case TFC. One item yet to be fitted is a totally authentic gunsight.

6 The Spitfire is a true fly-by-cable aircraft. Here you can see that the rear fuselage of EP120 has been restored to the same condition inside as out, including, where necessary, the replacement of as many of these complex fuselage frames as proved necessary.

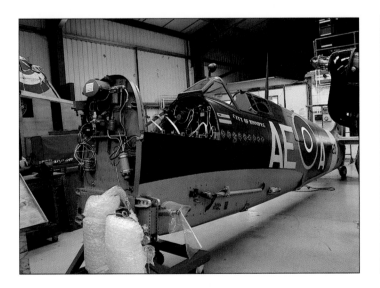

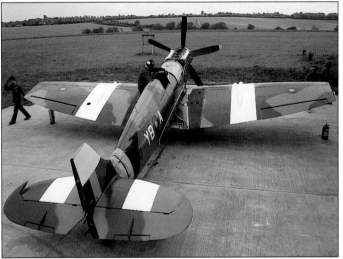

7 The fuselage of EP120 from the firewall behind which is the void for the 37gal upper main fuel tank. This will be fitted once all the cockpit instruments are in place. These items will require rear panel access for fitting and connecting. At the bottom of the firewall is the centre section spar to which the wing spar is bolted. This is the focal point for stresses between fuselage and wing.

8 The TFC Chief Engineer and Merlin guru, Pete Rushen, climbs into the cockpit of SM832 to make the first engine run marking the commencement of the engine tests. The tail of the Spitfire is tied down to ensure that SM832 cannot move even at high power settings. Although the engine is normally bench-tested after its rebuild, it is necessary to run it for a further two hours on the ground.

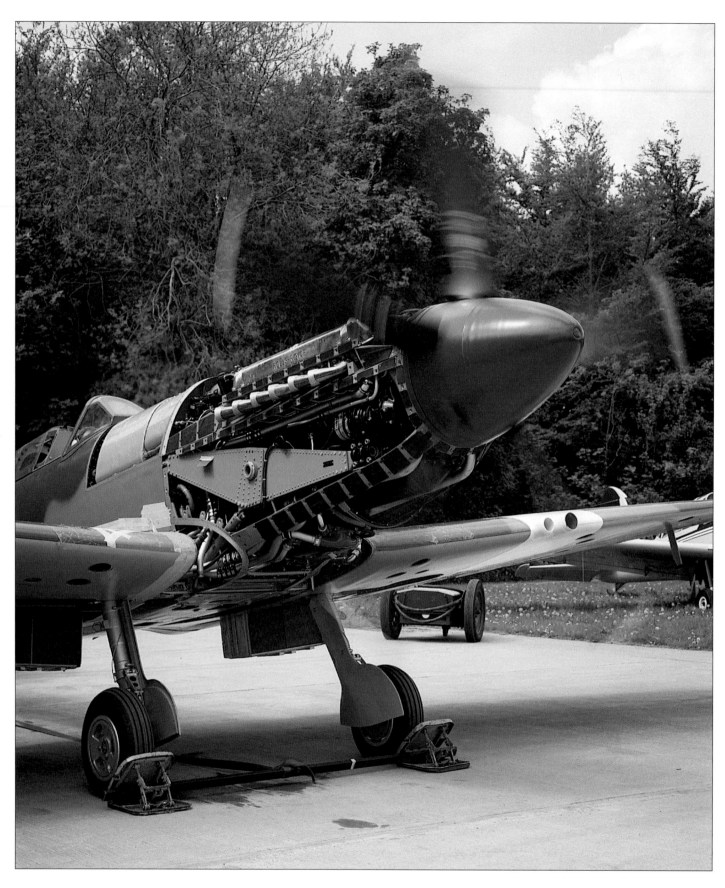

9 This period of ground running is to check out fully all of the systems and ensure that temperature and pressure readings at various power settings are achieved to within prescribed limits. Failure to meet these limits will require analysis to pinpoint the problem and identify whether it needs a simple on the spot fix or a more expensive job, requiring the engine to be removed and possibly stripped down.

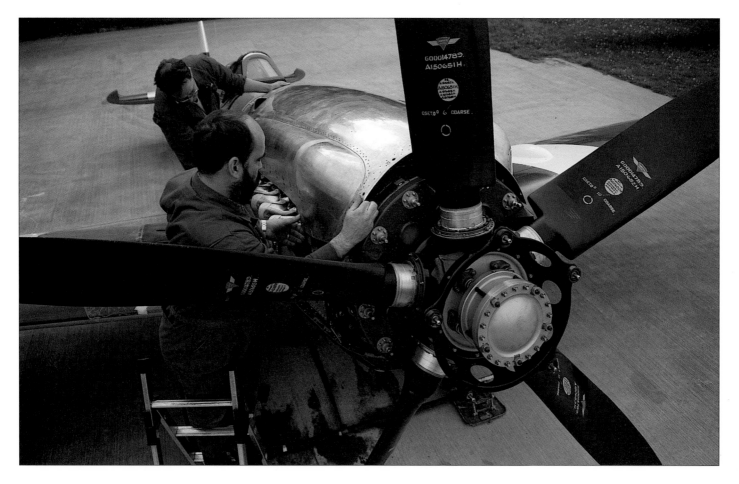

10 & 11 With the engine runs complete the missing panels and final items of equipment can be fitted. Test flying then follows a set programme allowing any problems to be rectified. When completed the cosmetic details will be finished as ordered and at last the customer can take delivery of his immaculate Spitfire possibly years after the project had started.

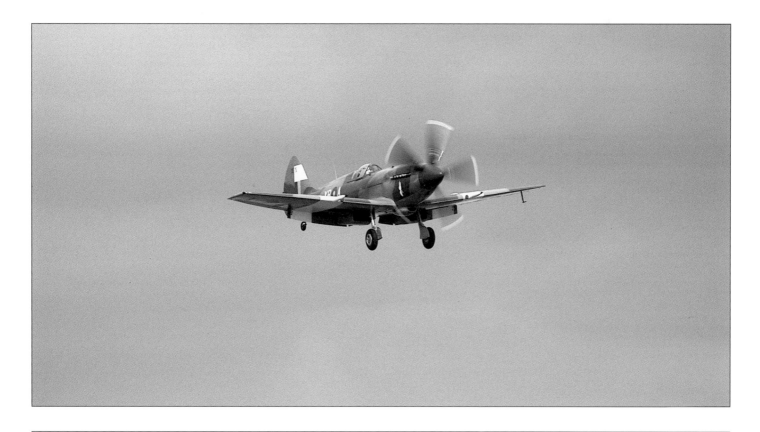

PROTOTYPE REPLICA

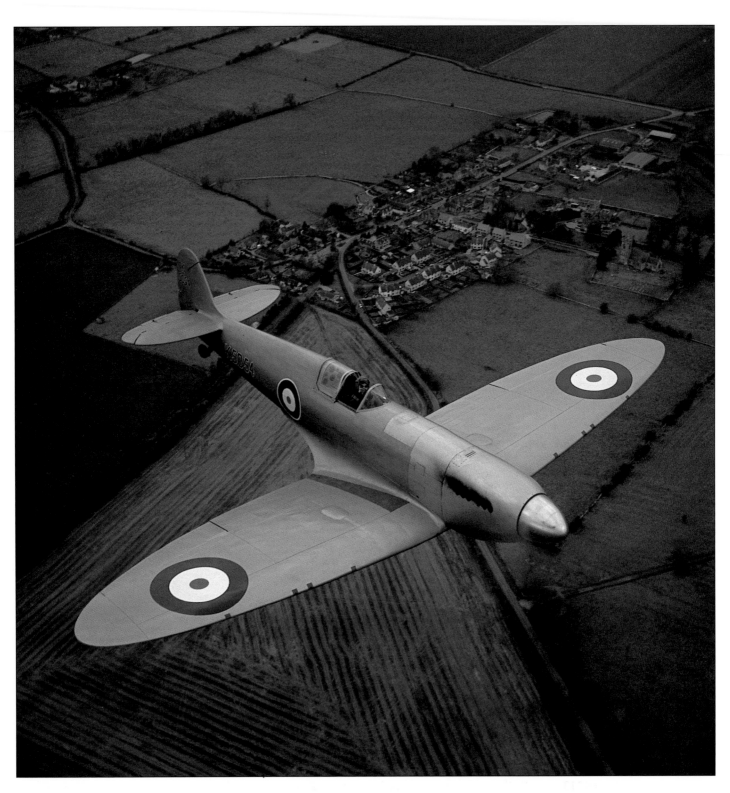

ABOVE: This replica of the prototype Spitfire was built by Clive Du Cros in Swindon over a period of 10 years. Using specially commissioned plans, this wooden Spitfire is built of Douglas fir and Sitka spruce covered in birch ply and powered by a modi- fied Jaguar V12 motor engine. Following a period of CAA test flights and a mishap in which one undercarriage leg collapsed on landing, K5054 (G-BRDV) is fully serviceable and is regu- larly flown from its Wiltshire base.

Mk I

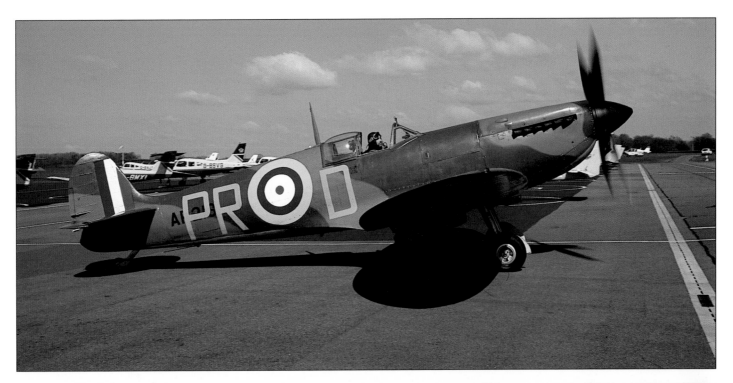

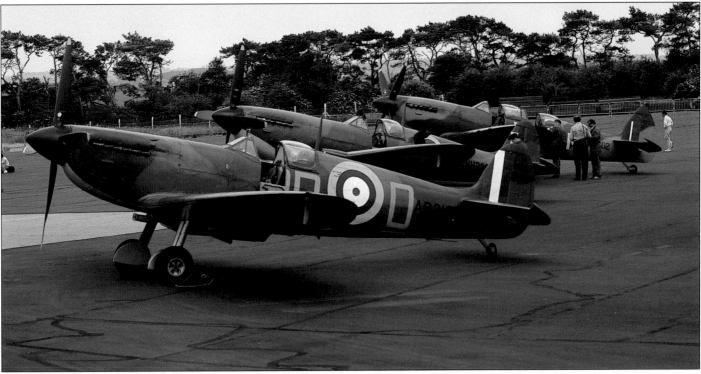

Top and above: AR213 (G-AIST) is the last airworthy Spitfire Mk Ia. Owned by Victor Gauntlet, she is based with PPS at Booker. One of many Spitfires built by Westland in 1941, she spent most of her wartime flying life with either No 53 or 57 Operational Flying Unit. Struck off charge in 1947 and purchased by the late Allen Wheeler, she spent the next 20 years in storage. AR213 was then surveyed and brought back to life for the making of the film *The Battle of Britain*. She has remained airworthy ever since and often graces the sky at airshows in the UK. AR213 is currently painted as PR-D representing No 609 Squadron of the Royal Auxiliary Air Force.

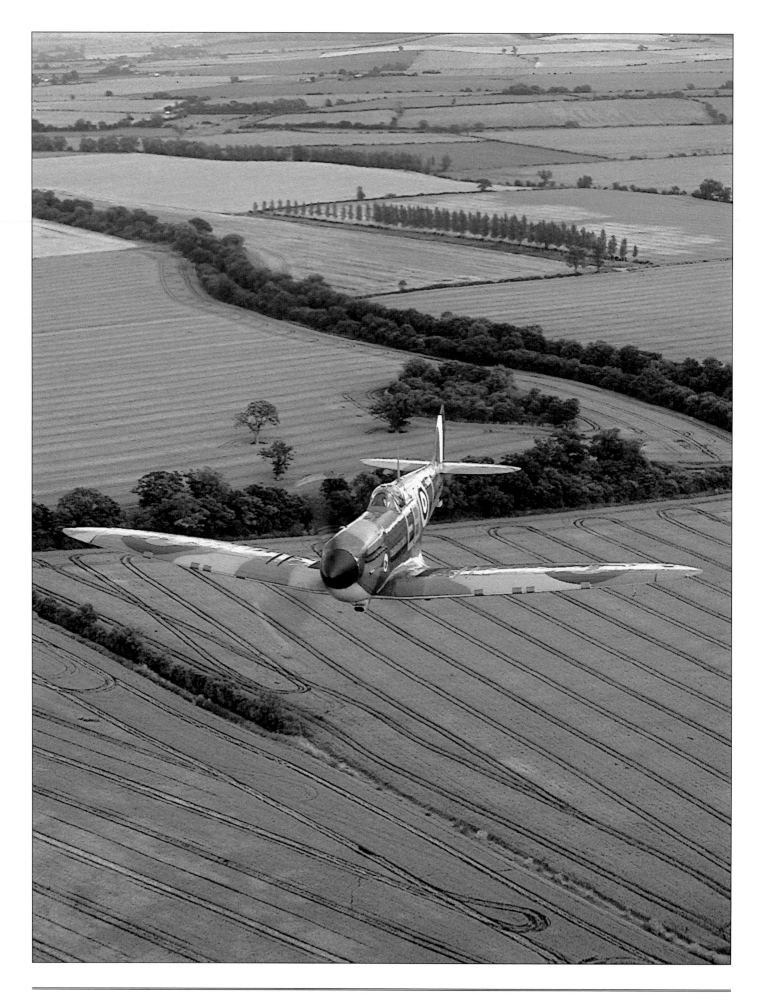

Mk II

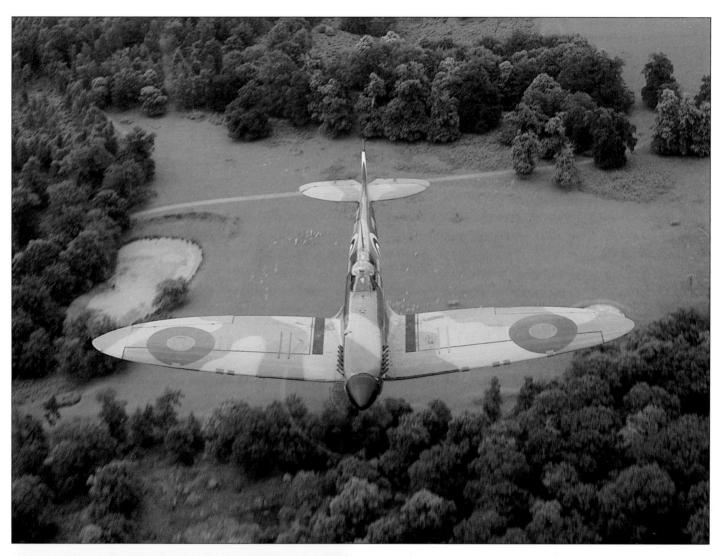

TOP AND OPPOSITE: The only airworthy Spitfire Mk IIa is P7350 (G-AWIJ) flown by the RAF's Battle of Britain Memorial Flight (BBMF). Ordered in 1938, she was the 14th Spitfire built at Castle Bromwich. Test-flown in August 1940 and delivered to the RAF later that month, she flew operationally with Nos 64, 266, 603 and 616 Squadrons and was credited with three kills before joining the Central Gunnery School, ending up with 57 OTU in 1944. During this time she suffered damage and had a couple of accidents requiring periods of repair. She was sold as scrap in 1946 for £25 but John Dale & Sons realised her significance and presented her to RAF Colerne museum. In 1967, P7350 was surveyed and overhauled for a flying role in the film *The Battle of Britain*. Then allocated to the BBMF, P7350 is illustrated here painted as EB-Z of No 41 Squadron. The BBMF is operated by the RAF as a tribute to those men and women, who sacrificed their lives during World War 2 fighting for our freedom. The BBMF flies a mixture of Spitfires and Hurricanes, along with a Lancaster and Dakota. The aircraft are repainted during each major service to represent units that took part in the war.

LEFT: The artwork applied to P7350 when she was painted in the markings of No 65 Squadron.

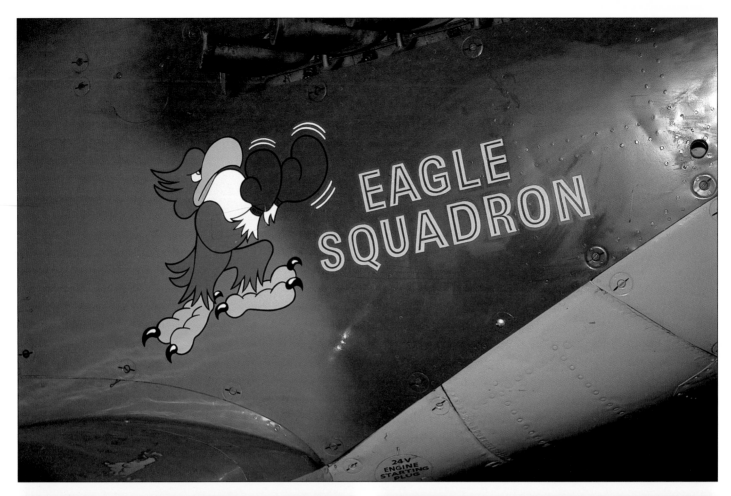

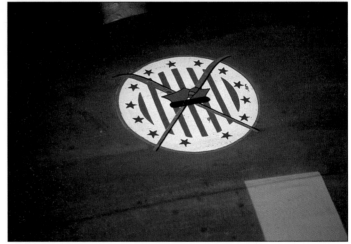

ABOVE LEFT: The aircraft code MD indicates No 133 (Eagle) Squadron - one manned by American volunteers. AB910 actually flew with the squadron during 1942. The E after the roundel indicates the individual aircraft within the squadron.

TOP AND ABOVE RIGHT: The American Eagle nose art and the stars and stripe motif (above right) are typical of the flamboyant style used by the American pilots to personalise their aircraft.

Mk V

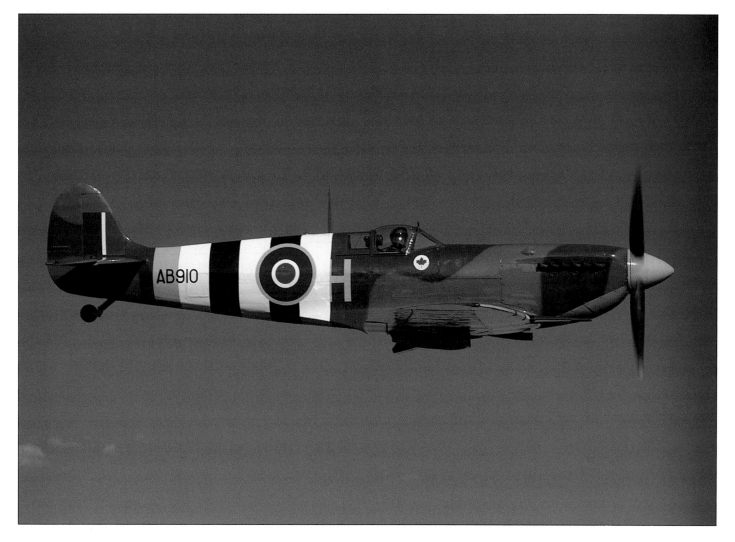

ABOVE: The Spitfire Mk V was seen as a stopgap variant pending the improvements planned to be introduced with the Mk VI. It was basically a Mk III airframe with strengthened longerons to take the more powerful Merlin 45. Initial models were fitted with machine-guns but these were soon superseded by the Vb which could take a combination of cannon and machine-gun.

AB910 (G-AISU) is a Spitfire Vb with the BBMF. Originally delivered to the RAF from Castle Bromwich and allocated to No 222 (Natal) Squadron in August 1941, she required repairs within one month. Three month later she was issued to No 130 (Punjab) Squadron but fared only slightly better before returning for repairs again. In June 1942 she was allocated to No 133 (Eagle) Squadron at Biggin Hill, transferring to No 242 (Canadian) Squadron in September. Two months later she was in storage with No 12 MU and in June 1943 AB910 was delivered to No 33 MU at RAF Lyneham for preparation to issue to No 416 (RCAF) Squadron the following month. Apart from a short spell with No 3501 Support Unit it would appear that she remained with the Canadians until April 1944 when she became a training aircraft with No 53 OTU.

While being prepared for a flight with No 52 OTU at RAF Hibaldstow AB910 was at the centre of a very unusual incident. It was usual practice during such preparations for the engine to be run briefly at full power and for of one of the ground crew to lean over the tailplane to prevent the tail lifting with subsequent damage to the propeller LACW Margaret Horton was give this task that day. At the controls was Flt Lt Neil Cox, who following what he thought was a successful test, took-off unaware that she was still on the tail! Due to the noise and vibration of the engine runs LACW Horton, too, was unaware as to what was happening and, before she realised it, they were airborne. The poor handling of the aircraft made Flt Lt Cox realise all was not well and so he elected to fly a circuit and land. It was a somewhat shocked pilot that peeled the much relieved, shaken and cold LACW Horton off the tail of his aircraft after they landed.

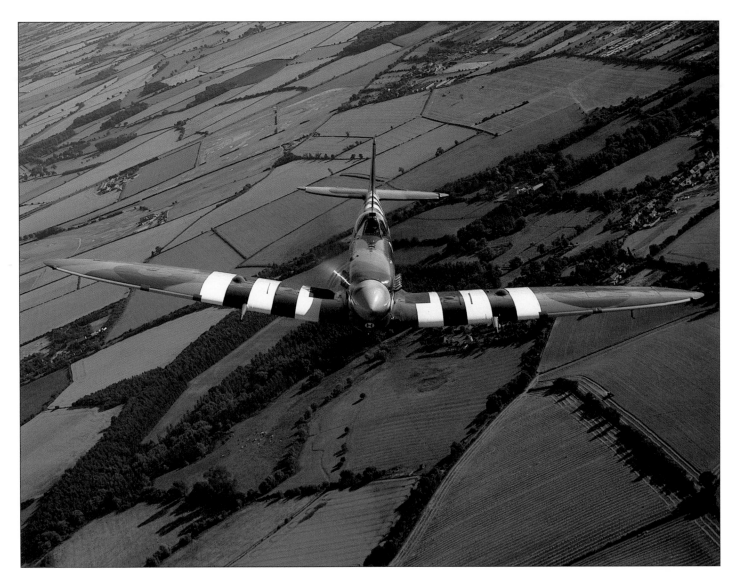

ABOVE: In May 1945 AB910 was allocated to No 527 Squadron for 11 months before six weeks with RWE. In storage with No 29 MU at RAF High Ercall, she was acquired by the late Grp Capt Allan Wheeler in July 1947. Painted blue, G-AISU was used for racing until sold to Vickers following an accident in 1951. Restored, she was painted back to a military scheme with the codes QJ-J and flown at numerous displays by test pilot Jeffrey Quill. In September 1965 AB910 was presented to the C-in-C Fighter Command and assigned to the BBMF. Here, finished with codes AE-H, AB910 is depicted in No 402 Squadron markings with the D-Day invasion stripes which applied to all aircraft for flights over the Normandy beaches from 6 June 1944.

OPPOSITE: AR501 (G-AWII) is a Spitfire Vc owned by the Shuttleworth Collection and based at Old Warden. She is fitted with the stronger 'universal' wing which was capable of being fitted with various permutations of armament - ranging from four .303in machine-guns through to a pair of 20mm cannon in each wing. Here, AR501 is fitted with a pair of machine-guns and a 20mm cannon. Red tape covers the machine-gun ports to protect them from freezing up because of the cold and damp while on patrol. The full designation of AR501 is LF Mk

Vc - the L indicating that the aircraft is optimised for low altitude work. To enable this type of aircraft to have a high rate of roll the outer section was removed to produce the 'clipped' wing. In the end there were more of the stopgap Mk V built than of any other mark - 94 Va, 3,925 Vb and 2,459 Vc - while only 100 of the Mk VI were constructed.

AR501 was a Westland-built Spitfire delivered to the RAF in June 1942. A month later she was assigned to No 310 (Czech) Squadron coded NN-D and was allocated to Sqn Ldr F Dolezal, DFC. It is in these markings that she appears today. In March 1943, AR501 was damaged and took until July to be repaired. From then on she served with a number of units including No 3501 SU, No 504 Sqn, Church Stanton Station Flight, No 312 (Czech) Sqn, No 442 (Canadian) Sqn, No 58 OTU, No 1 Tactical Exercise Unit, No 61 OTU and, following a period of repairs, the Central Gunnery School; she ended up at No 29 MU, High Ercall for storage in August 1945.

In 1946 AR501 became an instructional airframe at Loughborough College until 15 years later she was exchanged for a Jet Provost from the Shuttleworth Collection. Surveyed and restored to flying condition for *The Battle of Britain* film in 1967, she was eventually delivered to Duxford in 1973 for a two-year rebuild prior to being based at Old Warden.

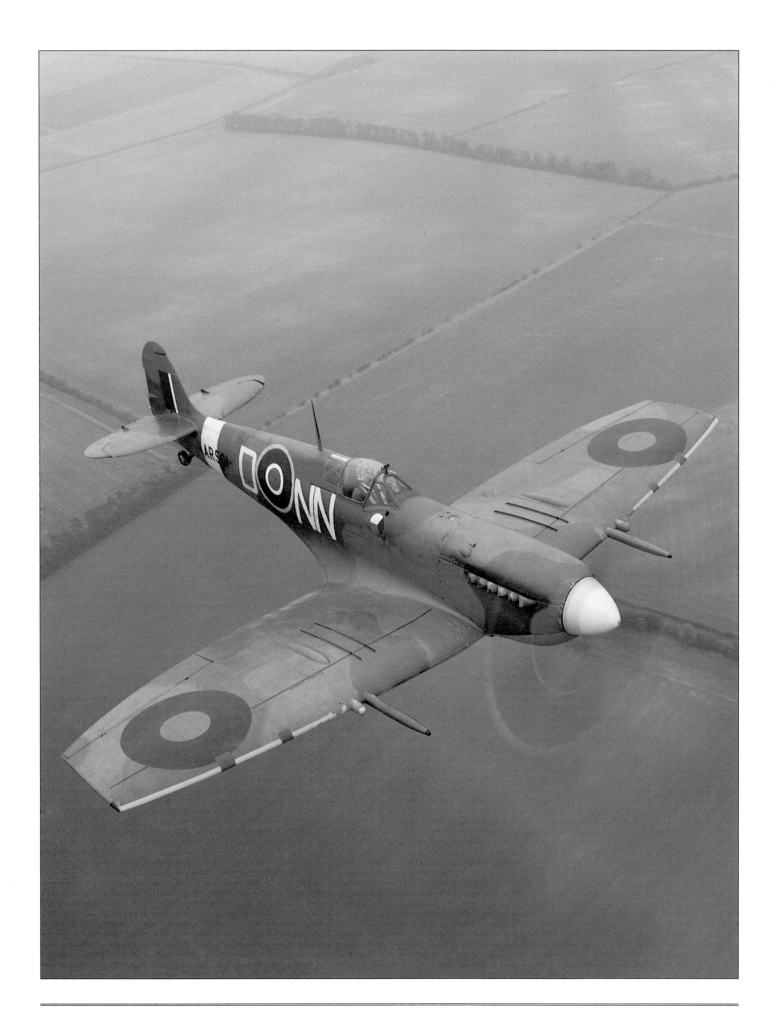

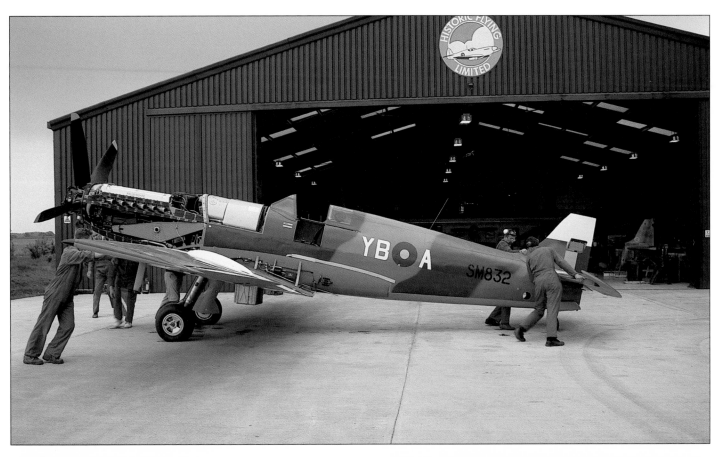

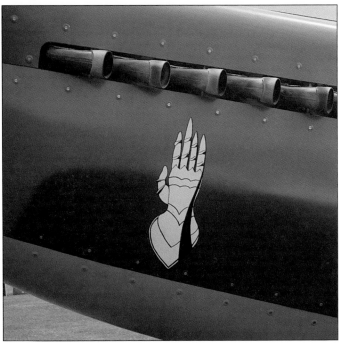

TOP: The Spitfire Mk VIII was an unpressurised version of the VII with a variety of engines depending on its role. The Merlin 61, 63 or 63A were standard but the Merlin 66 was fitted for the LF role and 70 for the HF. The Mk VIIIs were fitted with the 'c' wing developed for the Mk VII and could carry up to 1,000lb of bombs. The early production Mk VIIIs were fitted with almost pointed extended wingtips to give the extra lift required for high altitude intercepts. Here SM832, TFC's Spitfire Mk VIIIe, is pushed back into the Historic Flying hangar at Audley End after engine runs. She returned to the air in May 1995 and rejoined TFC's fleet at Duxford.

ABOVE LEFT: Close-up of SM832's No 17 Squadron gauntlet.

Mᴋ VIII

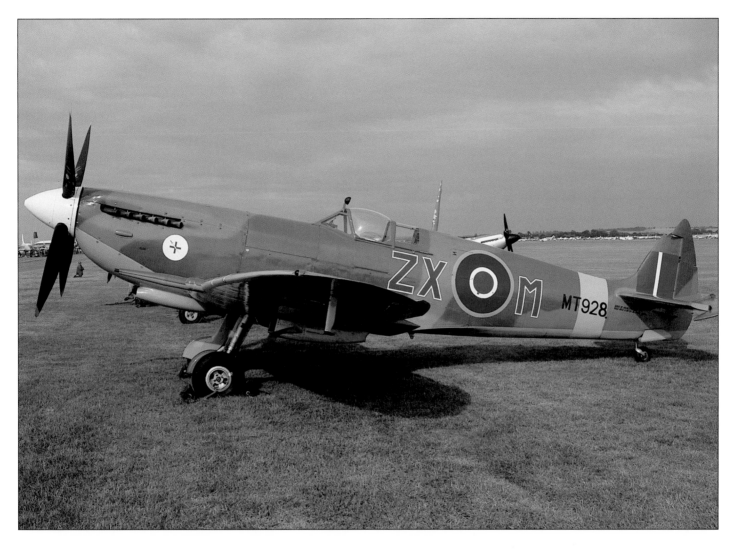

ABOVE: Spitfire HF Mk VIIc MV154 (G-BKMI) was built at Southampton and delivered to the RAF in September 1944. Test-flown twice with No 6 MU at RAF Brize Norton, she was transferred to the Preparation and Packing Depot of No 82 MU later that month. Once crated MV154 was shipped in October to Australia aboard SS *Port Fairey.* Arriving in Sydney in November, she was delivered to No 2 Aircraft Depot, RAAF and allocated the serial A58-671. Following inspection, MV154 returned back to No 2 AD for storage as the running down of Japanese opposition had resulted in a reduction in RAAF losses and a reduced replacement Spitfire requirement.

Authority to write off MV154 was given in May 1948 and she was transported to the School of Aircraft Construction in December still in her delivery crates. In October 1961, test pilot Sqn Ldr Oates acquired MV154 as part of a plan to estab-lish a memorial to Battle of Britain pilots. An application to obtain a C of A was turned down and eventually she was sold to Sid Marshall for his museum at Bankstown. Following his death, MV154 was sold to Robs Lamplough and shipped back to the UK for restoration. This was gradually completed over a 14-year period and final reassembly was undertaken at Filton prior to MV154 taking to the air again in May 1994. MV154 has been painted with the codes ZX-M to represent No 145 Squadron, when operational in North Africa in June 1942. MV154 is probably one of the least flown Spitfires in the world as it had just 2hr 4min logged from its early days with the RAF.

OPPOSITE, BELOW RIGHT: Close-up of the markings applied to the nose of MV154.

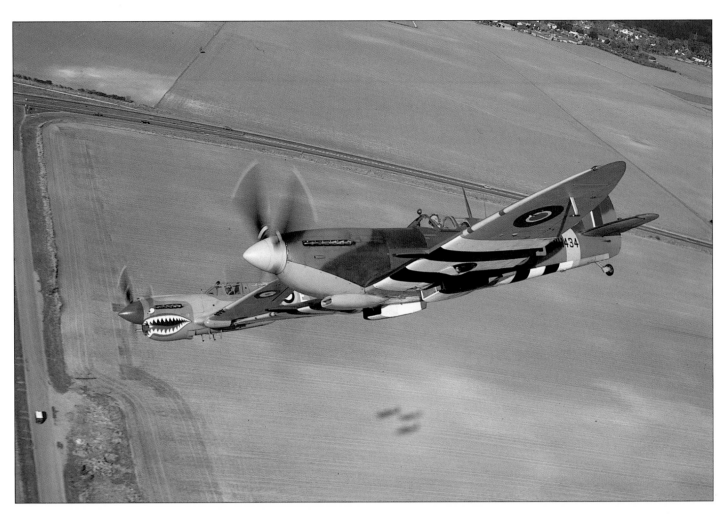

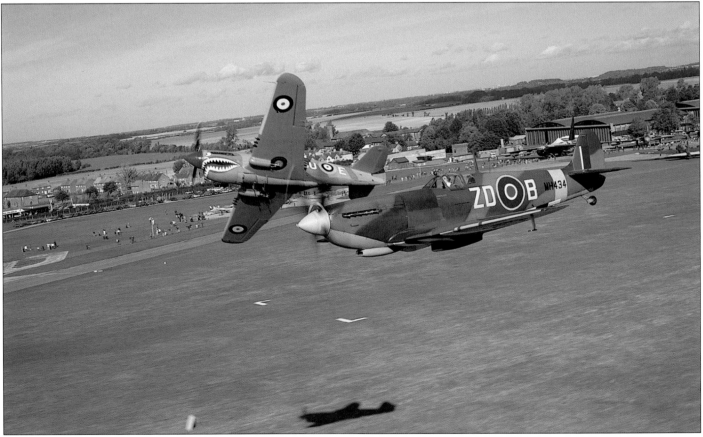

Mk IX

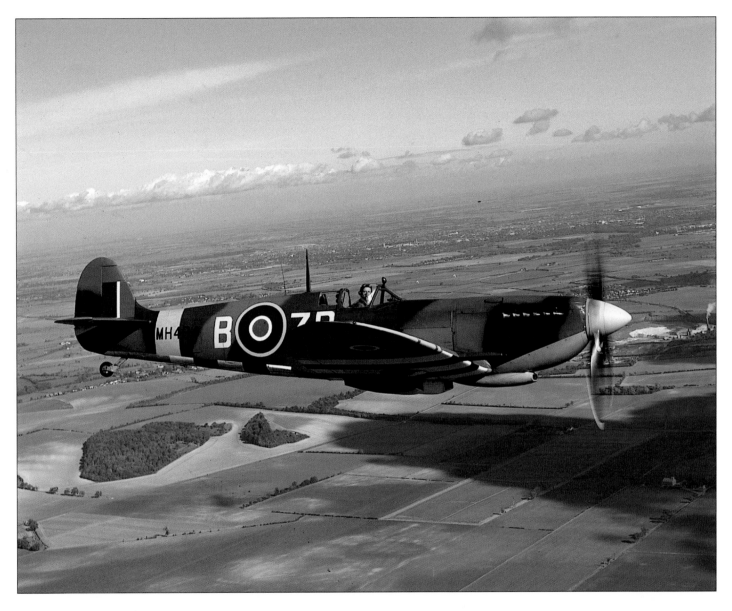

ABOVE: MH434 was built at Castle Bromwich in August 1943. She flew with No 222 (Natal) Squadron in the hands of South African, Flt Lt H P Lardner-Burke. On 27 August, during a 'Ramrod' escort for B-17s, she was credited with one Fw190 killed and another damaged. On 5 September a further Fw190 was shot down and a part share in a Bf109E was credited on the 8th. She then joined No 350 Squadron followed by Nos 222 and 349 Sqns. By March 1945 she was in store prior to disposal. Sold to the R Netherlands AF in February 1947, MH434 became H-05 of No 322 Squadron and saw operations against Indonesian Nationalists from December 1947 flying some 165 sorties including strafing and dropping 50 250lb bombs plus food and medical supplies for the troops. In July 1948 she was renumbered H-68. In May 1949 she suffered a belly landing and returned to Holland for overhaul by Fokker. Repaired, she was sold to the Belgian AF in October 1953 as SM-41. In 1956 SM-41 was sold to COGEA as target tug OO-ARA until bought by Tim Davies and based at Elstree as G-ASJV. Acquired in November 1967 for *The Battle of Britain* film she was sold afterwards to Adrian Swire and regularly appeared at airshows. In April 1983 she was sold again, this time at Christie's by auction for £260,000 to Nalfire Aviation and restored back to her No 222 Squadron markings. Nalfire became OFMC and she is flown regularly from Duxford for airshows and film work.

OPPOSITE: The OFMC Spitfire HF Mk IXb, MH434 (G-ASJV), flies formation with a P-40 around the Duxford area.

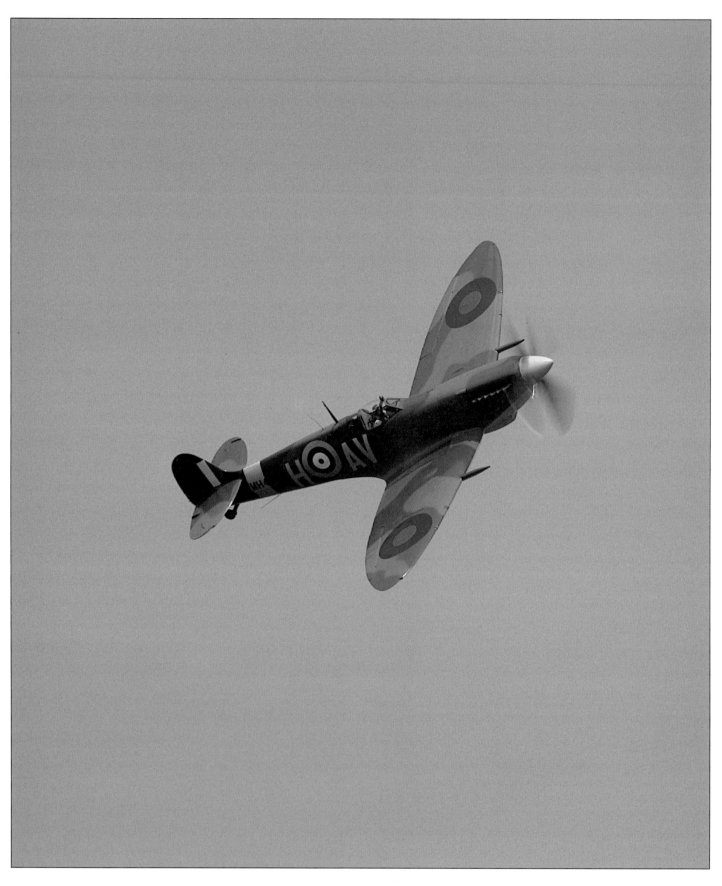

ABOVE: MH434 has been painted in a large number of schemes over the years, mainly for TV or film work. While markings applied on restorations are meticulously researched, those applied for many films and TV are purposely invented.

OPPOSITE: MH434 painted in Belgian AF colours. The codes are spurious having been applied during the making of *A Perfect Hero*.

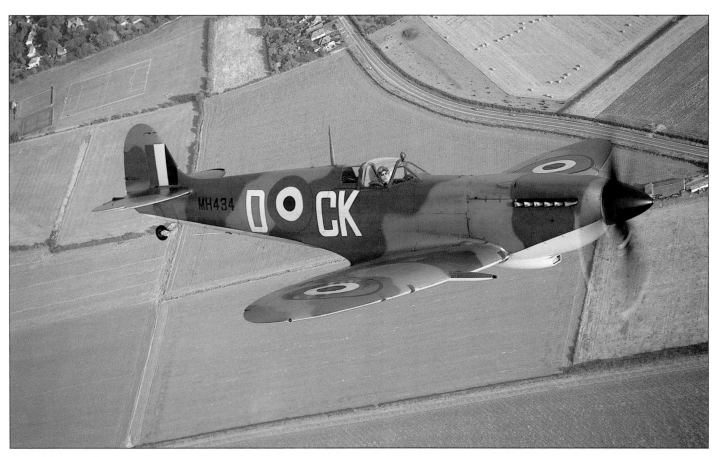

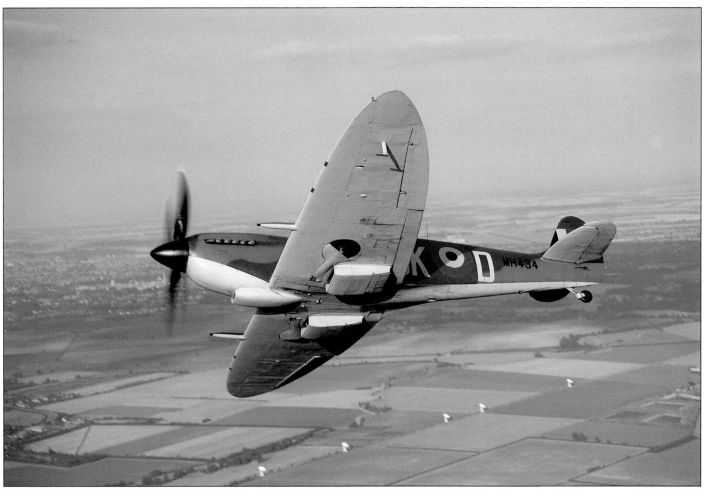

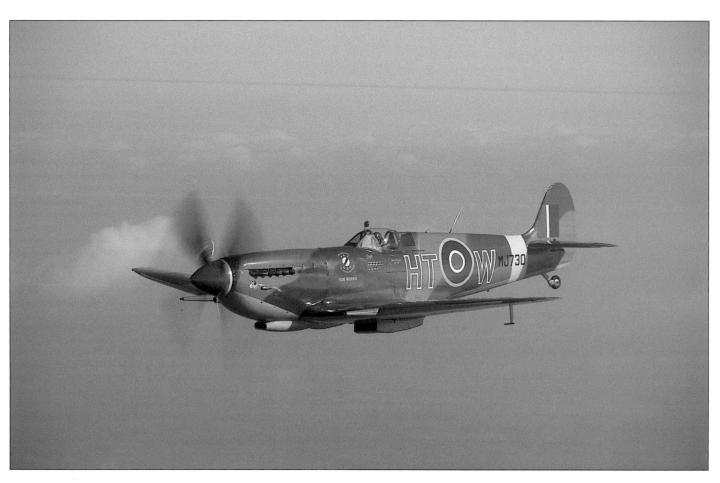

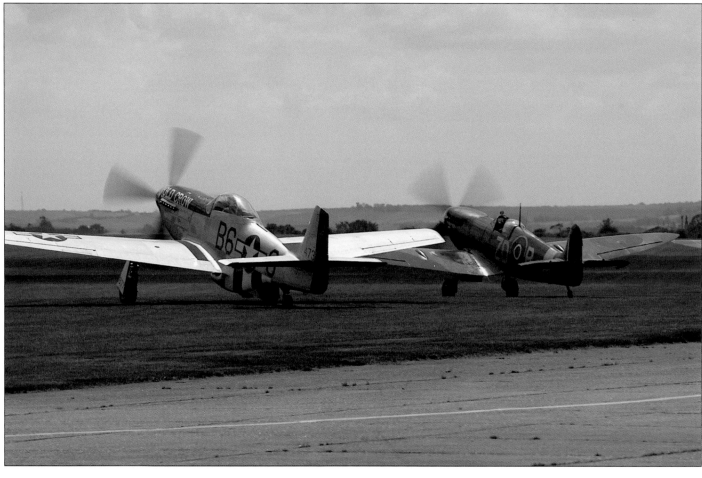

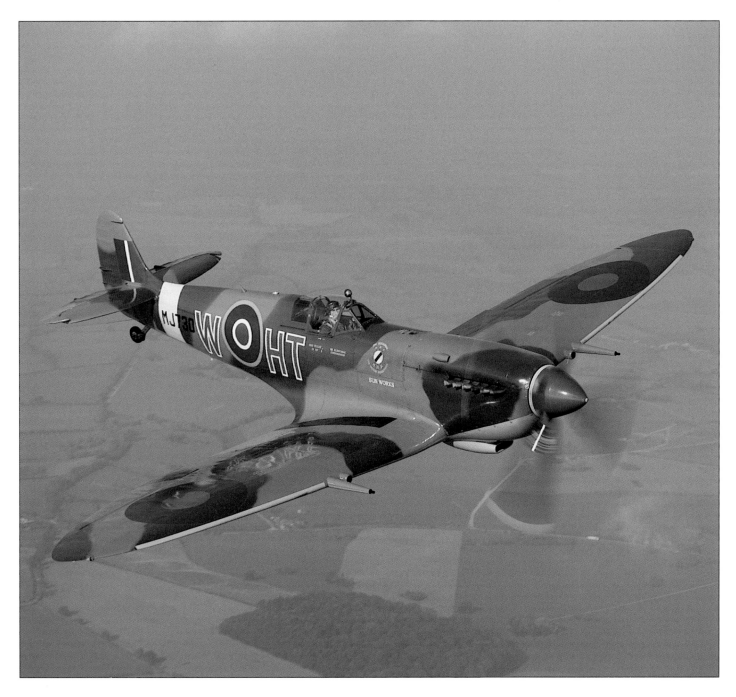

ABOVE AND OPPOSITE TOP: Spitfire HF Mk IXe MJ730 was built at Castle Bromwich in 1943 and delivered in December to No 33 MU, going shortly afterwards to No 222 MU for packing. Crated and shipped aboard SS *Leeds City*, she arrived in Casablanca in February. Although some of her records are difficult to follow, she was flown by No 249 Squadron as part of the Mediterranean Allied Air Force. Following the end the war, MJ730 was sold to the Italian AF in June 1946 and became MM4094. Four years later she was sold on to the Israeli AF as 0606 and later became 2066. No details of any military service are known until she was discovered derelict by Robs Lamplough at Kabri in 1976 and recovered back to Duxford. Restoration commenced in the hands of Steve Atkins of Aero Vintage at St Leonards-on-Sea for an American customer but she was later sold to David Pennell. Restoration was completed by Trent Aero and the aircraft was registered

G-BLAS; she is currently finished with the code HT-W which represents No 154 Squadron.

During World War 2 large collections were raised by towns and companies to help the war effort, the money often going towards an aircraft or another item of military hardware. In the case of an aircraft, a suitable inscription would be painted upon it - the markings here indicating that this aircraft was donated by the Sun Works.

OPPOSITE BOTTOM: MH434 with a P-51D Mustang at the end of the Duxford grass runway awaiting take-off clearance. Although the Mustang was originally ordered from North American for the RAF, the USAAF soon ordered it in large numbers and the type is considered to be the American equivalent of the Spitfire.

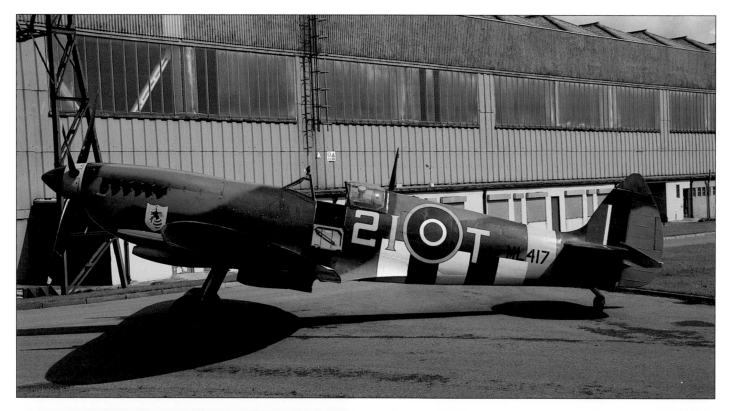

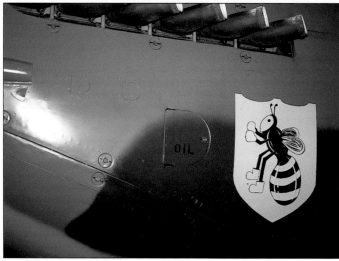

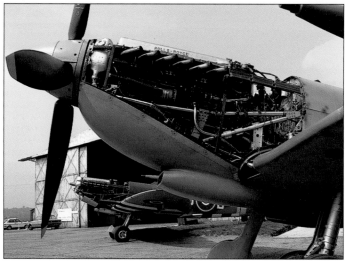

TOP: No 443 (RCAF) Squadron markings on TFC Mk IX ML417/G-BJSG.

ABOVE LEFT: Close-up of the unit markings on ML417.

ABOVE RIGHT: The Packard Merlin 266 fitted into ML417.

OPPOSITE TOP: ML417 in an early camouflage for the TV series *Piece of Cake*. Castle Bromwich-built ML417 was delivered to the RAF during April 1944. By June she was allotted to No 443 (RCAF) Squadron coded 21-T. Flown on D-Day, on 26 June her pilot - Flt Lt Prest - claimed an Fw190 as damaged/probable over Rouen. On 13 July a damaged/probable

Bf109 was claimed and on 29 September ML417 in the hands of Flg Off Hodgins, two Bf109s were claimed destroyed. ML417 later spent time with Nos 401, 411 and 442 Sqns then went into storage at No 29 MU. She was sold to Vickers in October 1946 for conversion to T9 status and flown as G-15-11 before delivery to the Indian AF as HS543. Little is known of her Indian exploits and she was acquired by Senator Gaar in 1967 for restoration in the USA. Little happened until she was acquired by TFC and restored to her stock single-seat fighter configuration by PPS at Booker; she took to the air again in February 1981.

OPPOSITE BOTTOM: MK732 of the Dutch Spitfire Flight.

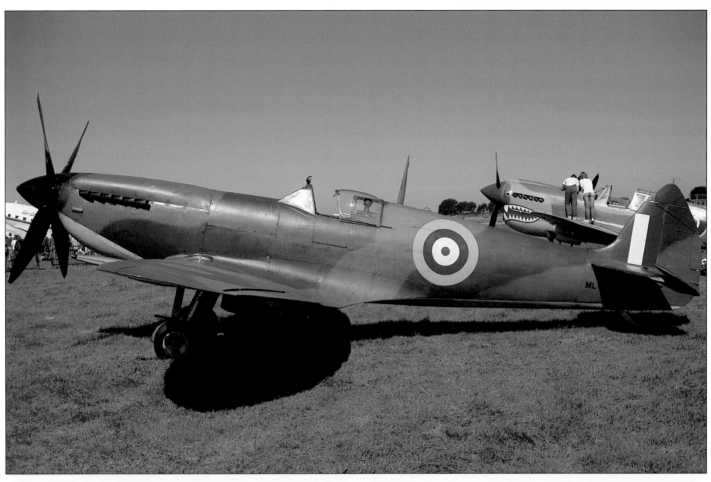

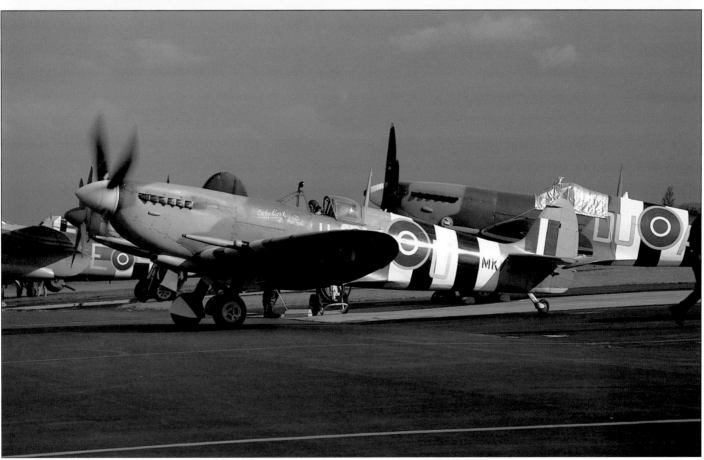

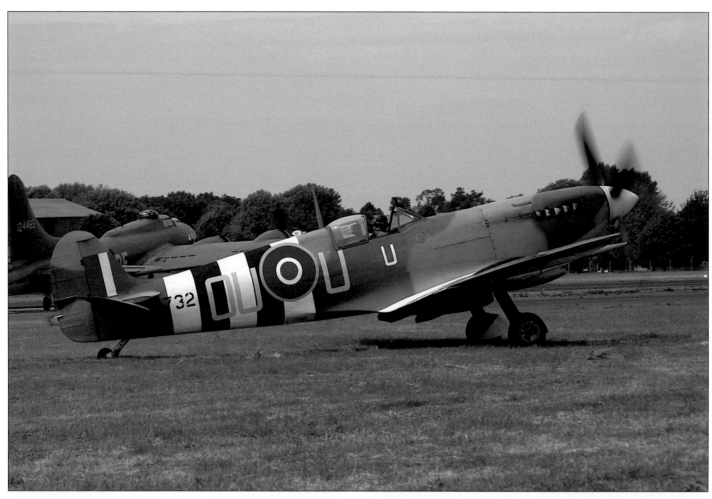

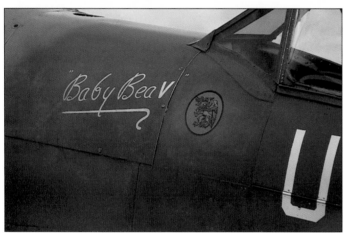

TOP: The restored MK732 OU-U in No 485 Squadron markings. Built by Castle Bromwich, MK732 was delivered to the RAF in March 1944 and issued to No 485 (RNZAF) Squadron in April coded OU-Q. On D-Day, Flt Lt K L Macdonald claimed a part kill of a Ju88 and Plt Off Patterson claimed an Fw190 two days later. MK732 flew in Operation 'Market Garden' at Arnhem and may be the last surviving Spitfire from that operation. Her operational flying ended in September and she finally made storage in January 1945. Sold to the R Netherlands AF in June 1948, she became H-25 with JVS in March 1949 and retired as a decoy in June 1954. 'Borrowed' by No 14 Squadron for a wing trophy, she returned to the UK

for rebuild but instead was stripped to keep the BBMF aircraft flying. Later, MK732 was returned to Holland for restoration. With help from the R Netherlands AF, the Dutch team together with Steve Atkins, the project progressed until 10 June 1993 when MK732 returned to the air.

ABOVE LEFT: MK732 was named *Baby Bea* V by Plt Off H W B Patterson after his finacee Beatrice.

ABOVE RIGHT: Unit badge on TE566.

OPPOSITE: TE566 painted as DU-A .

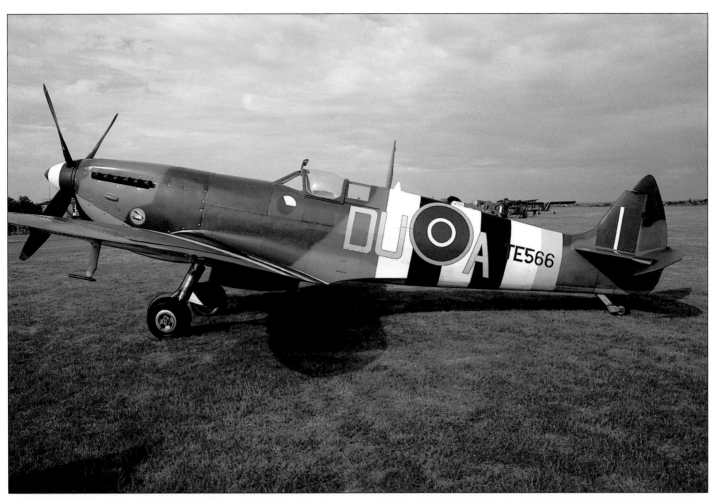

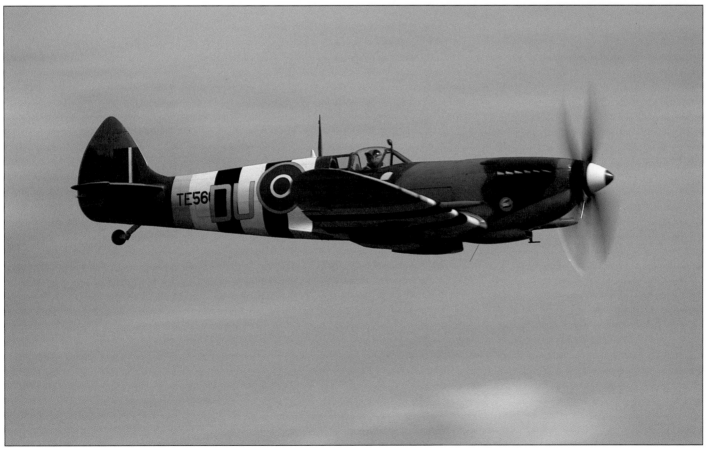

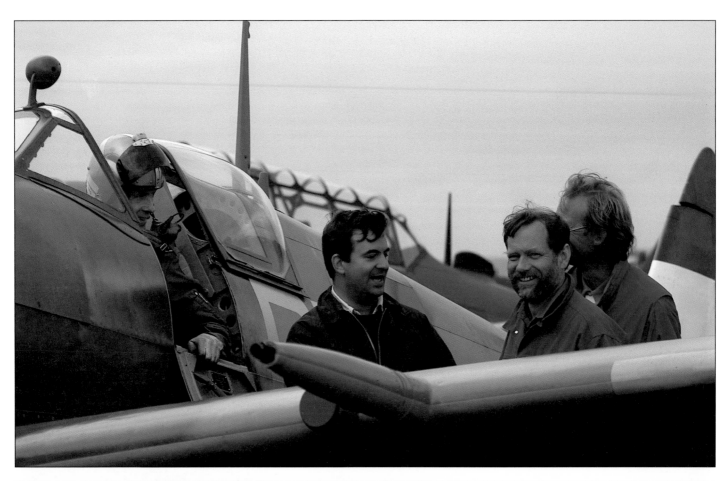

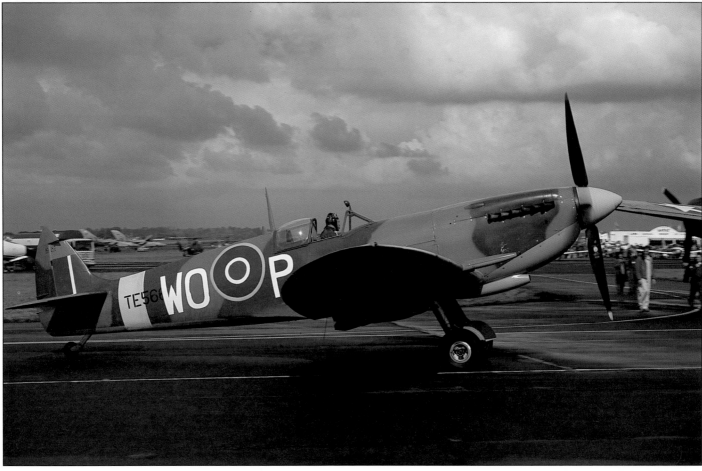

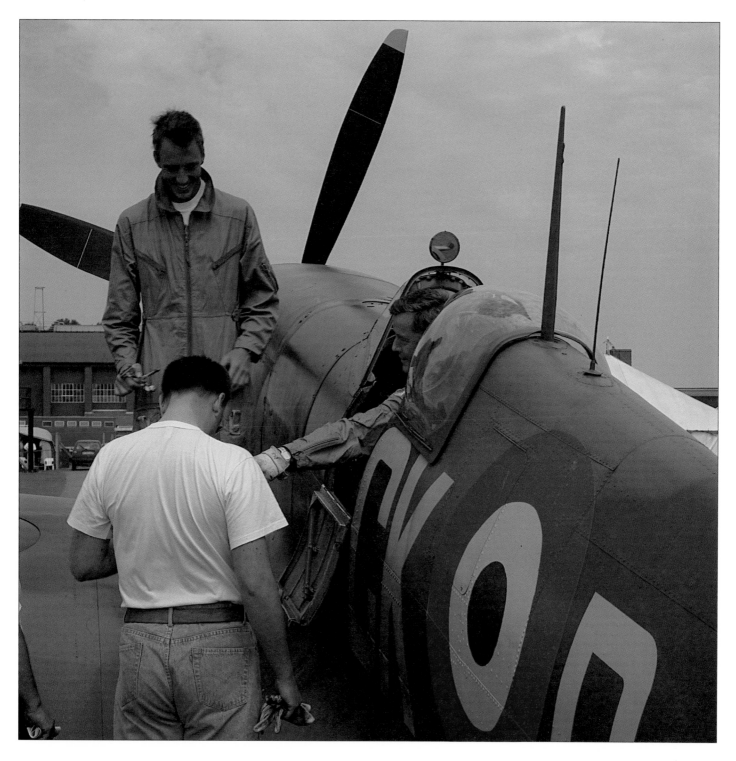

ABOVE: Mark and Ray Hanna discuss a display sequence with Nick Grey of the Fighter Collection.

OPPOSITE TOP: Spitfire LF Mk IXe TE566 has a somewhat vague background as the records have been lost. It is thought that she was probably built at Castle Bromwich in the early part of 1945. She was initially delivered to No 312 (Czech) Squadron but no details of her operational history are known. In August 1945 she was flown from No 33 MU at RAF Lyneham to RAF Manston where she was painted in Czech AF markings with the codes DU-A prior to the onward flight to

Czechoslovakia. In 1949 she was sold to Israel and became IAF-2032. Again little is known of this period other than that she was eventually discovered in a kibbutz playground at Alonim and brought back to the UK by Robs Lamplough in 1976. Subsequently sold to Guy Black, restoration commenced with Vintage Airworks and was completed by Historic Flying.

The photograph shows the historic day in 1993 when TE566 returned for the Czech air show at Roudnice with Charlie Brown (in the cockpit), Tim Routsis and Guy Black.

OPPOSITE BOTTOM: TE566 painted as WO-P for a TV film.

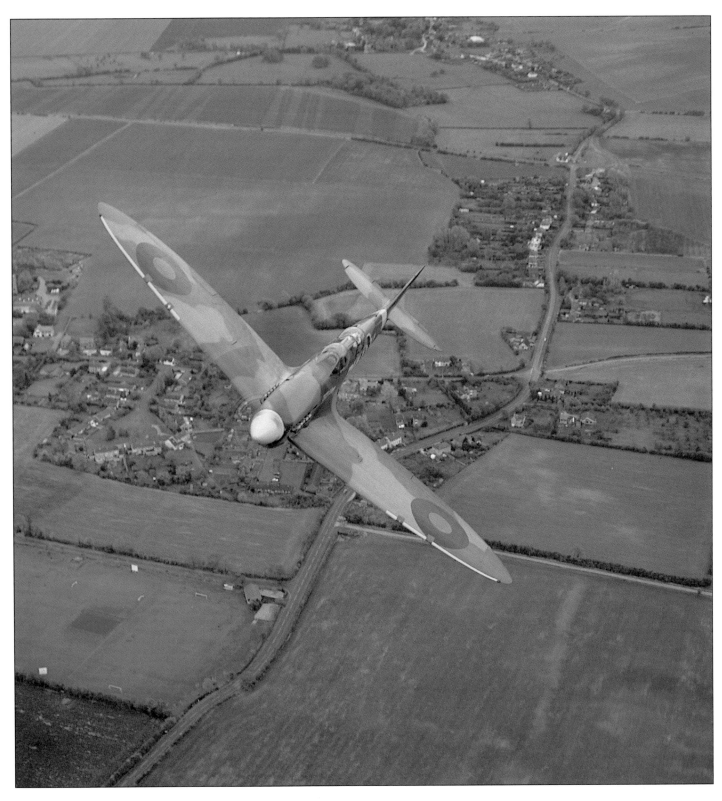

ABOVE: Spitfire T9 ML407/G-LFIX, owned by Carolyn Grace and seen in No 485 (RNZAF) Squadron markings.

ML407 was built at Castle Bromwich as an LF Mk IXc and delivered to the RAF in April 1944. She joined No 485 (RNZAF) Squadron, coded OU-V and flew a total of 137 sorties during which two Ju88s were downed (one shared) and two Bf109s plus another aircraft were damaged. She flew briefly with a number of other units including No 341 (Alsace) Squadron before ending the war in store. She was sold

to Vickers in July 1950 for conversion to T9 for the Irish Air Corps as IAC162. Retired in 1960 and sold in 1968, she passed hands several times until bought by the late Nick Grace in 1979 for restoration which saw ML407 back in the air again in April 1985. Sadly Nick was killed in a motoring accident but his wife, Carolyn, completed Nick's wish for her to be able to fly the Spitfire, working hard to achieve a CAA Display Authorisation.

T Mk 9

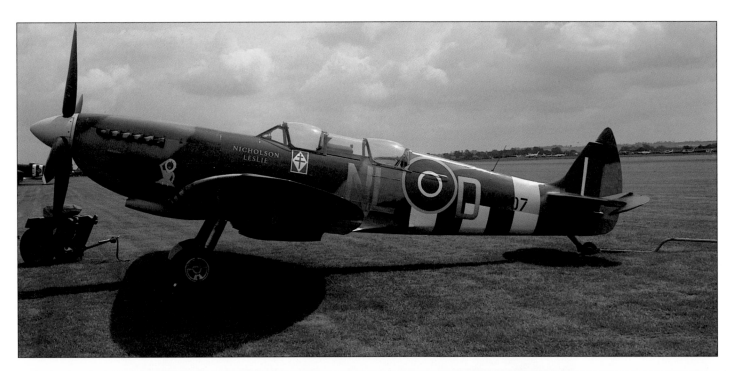

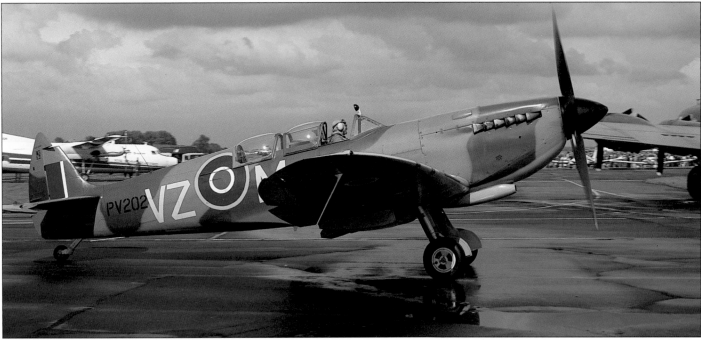

TOP: ML407 in No 341 (Alsace) Squadron markings.

ABOVE: Spitfire T9 PV202/G-TRIX in No 412 Squadron markings. PV202 was built as an LF Mk IX at Castle Bromwich and delivered to the RAF in September 1944. In October of that year she was allocated to No 33 Squadron in Northern France for two months. Transferred to Holland with No 412 (RCAF) Squadron as VZ-M, on 17 March Plt Off Grant shot down an Fw190 and eight days later Sqn Ldr Boyd shot down a Bf109. By April they had moved into Germany and on 29 April an Fw190 was shot down by Flt Lt Maclean and the last of 76 operational sorties was flown in May. On returning to the UK she entered storage at No 29 MU in July and remained there until July 1950. From here she followed a parallel course to ML407 becoming G-15-174 and then IAC161. Purchased by Nick Grace in 1979 she was sold to Steve Atkins, initially registered G-BHGH and then G-TRIX, and took to the air in February 1990 after a lengthy restoration.

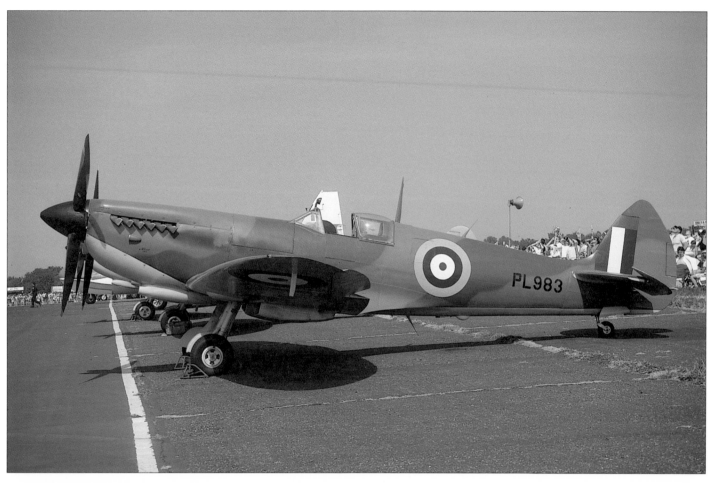

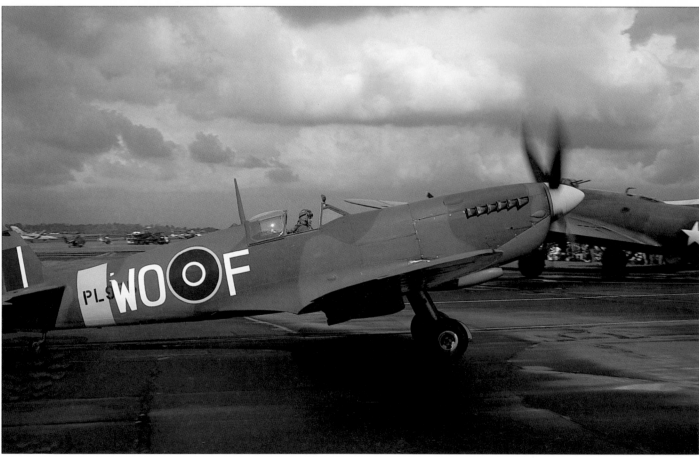

Mk XI

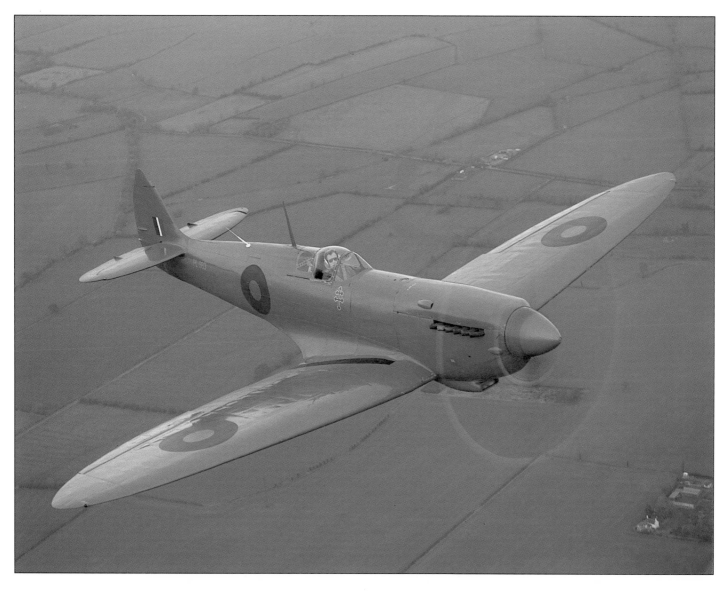

OPPOSITE TOP: PR Mk XI PL983/G-PRXI in camouflage for a film.

OPPOSITE BOTTOM: PR Mk XI PL965/G-MKXI camouflaged for TV. PL965 was assembled at Aldermaston, delivered to the RAF in October 1944 and issued to No 1 Pilots Pool at RAF Benson (PR HQ) in January 1945. Allocated to No 16 Squadron, she flew from various continental locations from mid-January until September when she returned to the UK. In July 1947 PL965 was one of eight Spitfires sold to the R Netherlands AF with whom she was used for technical training until 1952. Painted as a Mk IX, she was moved to the National War and Resistance Museum at Overloon in November 1960. In April 1972 her identity was re-traced and she was restored by RAF Bruggen. Acquired by Chris Horsley in 1987, restoration to flying condition has been completed.

ABOVE: PL983 in No 4 Squadron, 2nd Tactical Air Force PRU blue colour scheme. PL983 was also assembled at Aldermaston in 1944, delivered in October and with No 1 Pilots Pool in November. In January she joined No 4 Squadron followed by No 2 Squadron in September. The following January she commenced a period around various MUs. In July 1947 PL983 was supplied to Vickers Armstrong to loan her to the US Air Attache. She was flown by ex-ATA pilot Lettice Curtice from Eastleigh to Hendon for handing over as NC74138 in January 1948 to Livingstone Satterthwaite for the US Embassy Flight. Later returned to Vickers she was finally given to the Shuttleworth Collection. In 1975 she was moved to Duxford for restoration but in 1982 funds were desperate and a decision to sell saw her realise £110,000 at the auction to ex-fighter pilot Roland Rraissinet. Restoration was completed in the hands of Trent Aero and PL983 flew again in July 1984 with the civil registration G-PRXI.

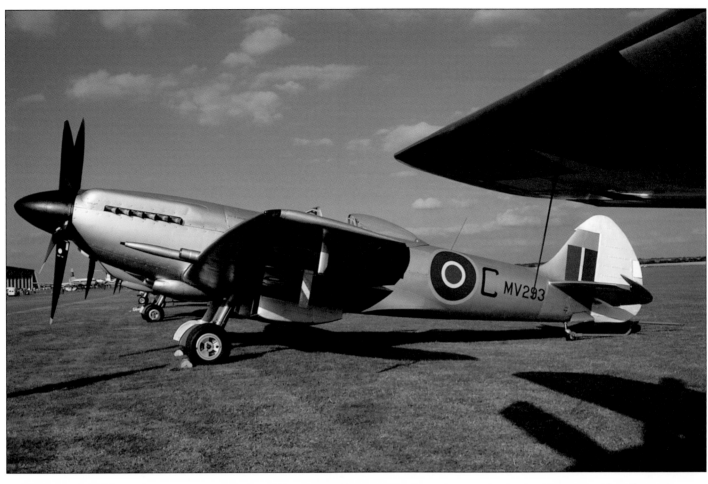

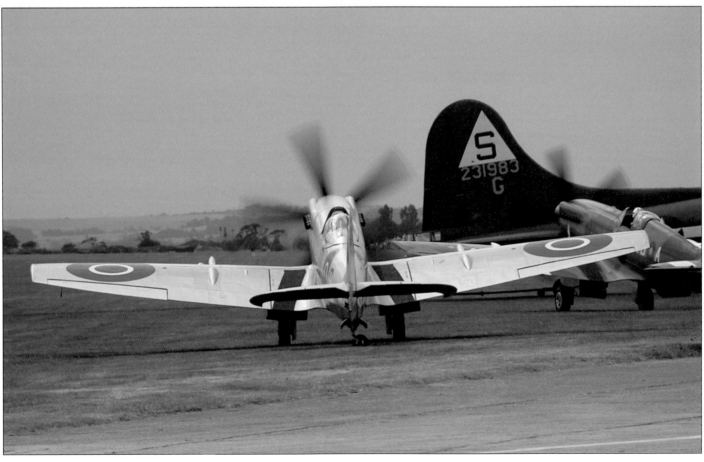

MK XIV

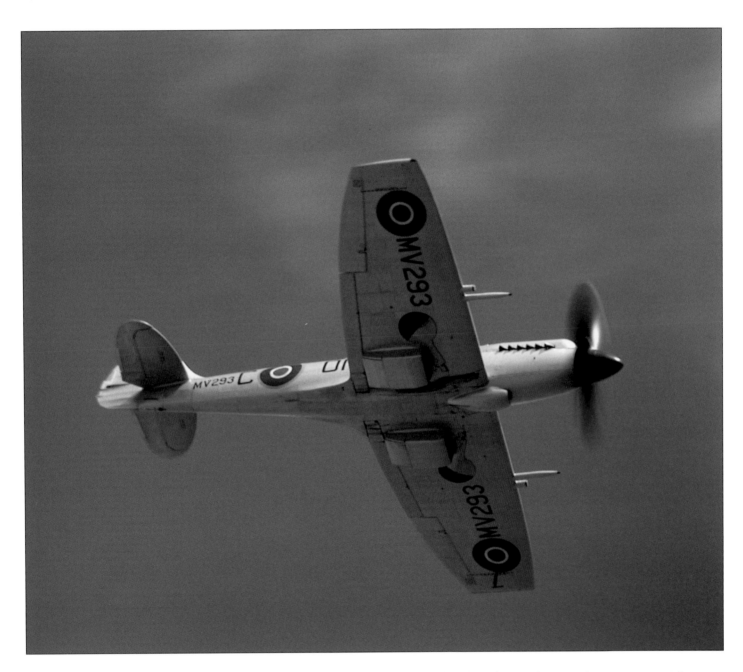

ABOVE: The effect of the clipped wing gave the pilot an improved manoeuvrability for the low flying Spitfires but it spoilt the aesthetics of Mitchell's elliptical wing shape.

MV293 was built at Keevil, delivered to the RAF in February 1945 and placed straight into storage with No 33 MU at nearby RAF Lyneham. In August she was transferred to No 215 MU for packing ready for shipping to India. September saw her on board the SS *Deelank* on her way to Karachi. MV293 arrived in India in October and was listed in the May 1946 India Census. At the end of December 1947 she was one of a batch of RAF aircraft sold to the Indian AF. Unfortunately, nothing is known of her Indian military service record other than she was later used as a training airframe at the IAF Technical College at Jalahalli and was given the code T20.

OPPOSITE TOP: Making a sharp contrast to the usually camouflaged Spitfire, MV293/G-SPIT looks immaculate in her metallic finish.

OPPOSITE BOTTOM: The pilot's problem of handling a powerful tail dragger on the ground becomes starkly obvious at this angle. The only way to move safely is to zig-zag enabling one to look around the side of the engine.

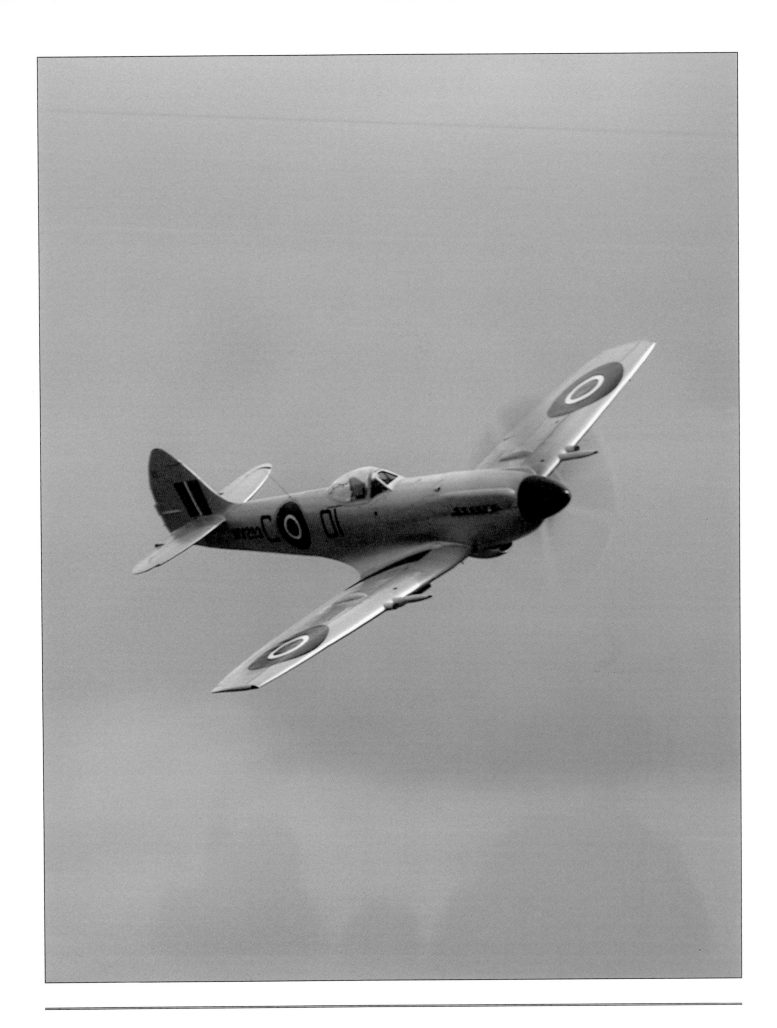

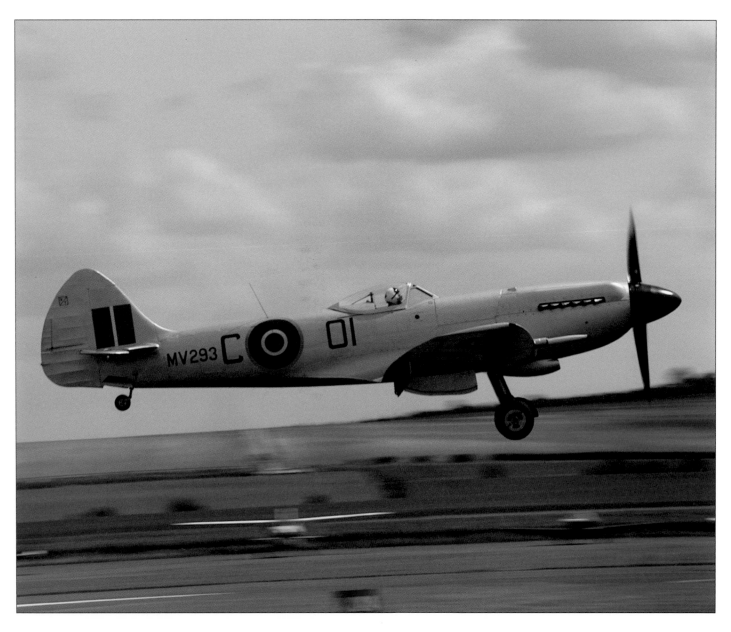

ABOVE AND OPPOSITE: T20 was discovered at Bangalore by the late Ormond Haydon-Baillie, purchased and shipped back to the UK in 1978 for restoration and registered G-BGHB. Sadly Ormond was killed in a flying accident and the aircraft collection had to be sold. MV293 was bought by Warbirds of Great Britain and re-registered G-SPIT in March 1979. In October 1985 this restoration project was taken over by TFC and completed at Duxford. MV293 flew again on 15 August 1992 and has been finished as OI-C of No 2 Squadron.

At a time when every aircraft was vital to defend against the Luftwaffe, the Supermarine factory at Woolston and the new Vickers shadow factory at Castle Bromwich rapidly became major targets for the Germans. In September 1940 a series of attacks on Woolston eventually managed to destroy the factory. Fortunately the attacks on Castle Bromwich were not as successful because if production had been interrupted at Castle Bromwich the result would have been disastrous.

A plan was devised for dispersed production and a number of sites across Wiltshire, Berkshire and Hampshire were found. These included motorcar and bus garages, engineering works and even furniture factories. The idea was that a number of sites in a given area would produce the various components and the bigger premises would build the sub-assemblies such as fuselages and wings that would be moved at night to a final assembly point usually on an airfield to enable the finished aircraft to be flown out. MV293 was built this way with the sub-assemblies being made up at various locations in Trowbridge and the final assembly carried out on the airfield at Keevil. Nearly 600 Spitfires of various marks were completed at Keevil but before it opened a further 300 sets of components were assembled at Trowbridge and the final assembly and flight carried out at High Post.

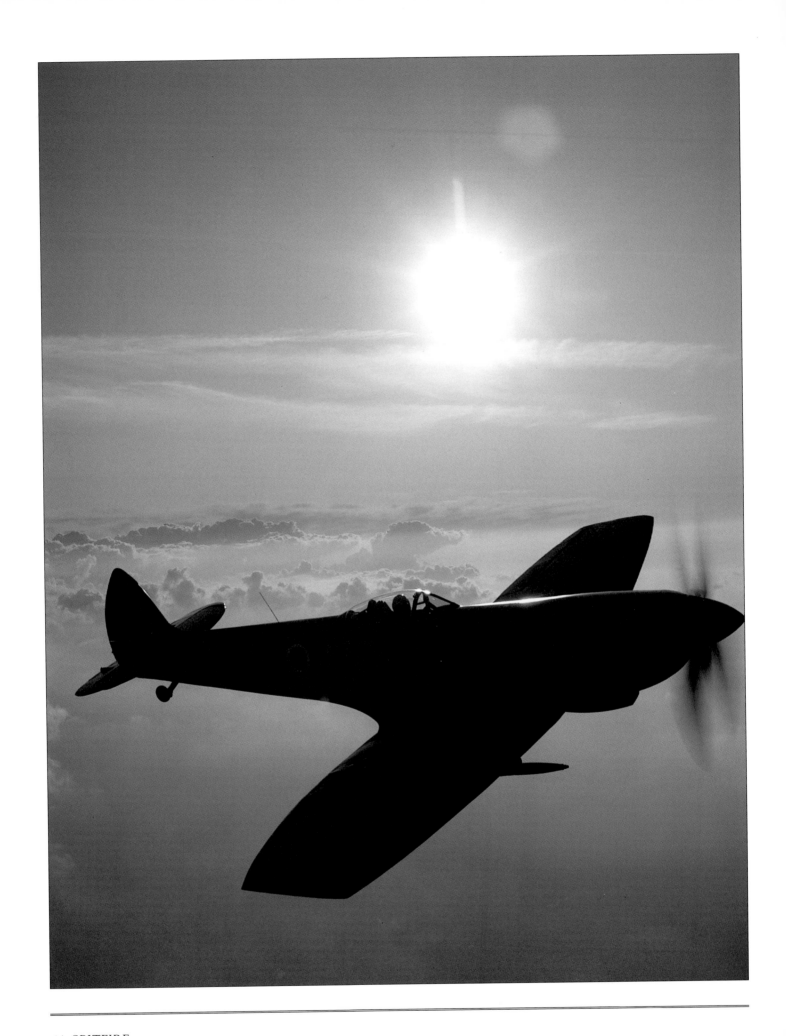

Mk XVI

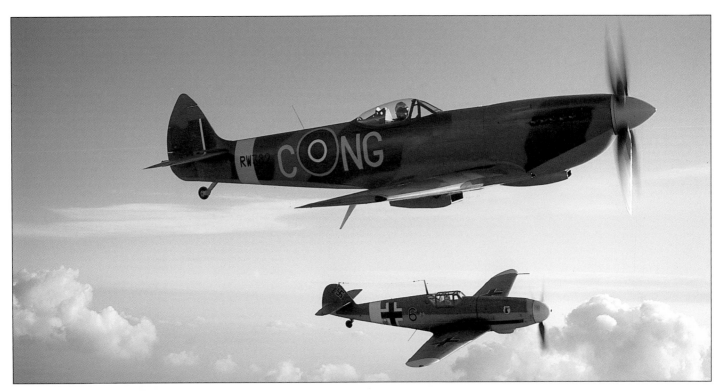

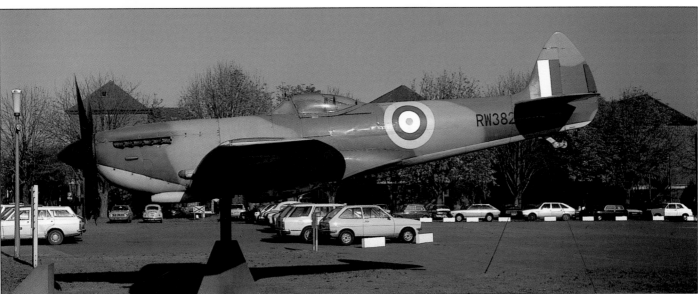

TOP: RW382/G-XVIA in formation with a Messerschmitt Bf109G-2.

ABOVE: RW382 mounted on a pole on the gate of RAF Uxbridge. Following a previous precedent set when WoGB exchanged three Spitfires for aircraft for the RAF Museum, Tim Routsis of Historic Flying patiently commenced negotiations with the Ministry of Defence in 1985. They spanned three years and, in the end, five Spitfires that were displayed as gate guards were relieved of their duties. All of these historic aircraft had been parked and open to the elements and had gradually deteriorated over the years. In exchange MoD would receive a P-40 Warhawk and Bristol Beaufort, both to be provided by the Military Aircraft Restoration Co for the RAF Museum; in addition, 12 Spitfire and Hurricane full size GRP replicas were to be provided for use as gate guards.

OPPOSITE: Ex-gate guard RW382/G-XVIA back in the air.

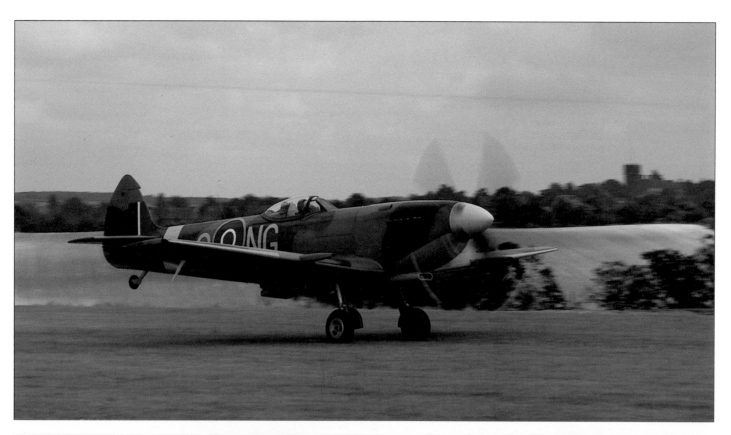

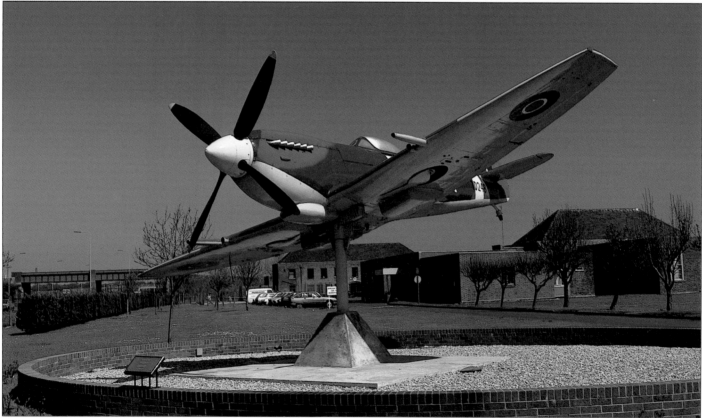

TOP: RW382/G-XVIA, restored by Historic Flying for David Tallichet, seen landing as NG-C of No 604 Squadron RAuxAF. This Spitfire is now in the USA and owned by Bernie Jackson.

ABOVE: TD248 on top of a pole on the gate of RAF Sealand.

OPPOSITE TOP: TE248 restored by Historic Flying to No 41 Squadron colours for Eddie Coventry.

OPPOSITE BOTTOM: TE476 on the gate of RAF Northolt.

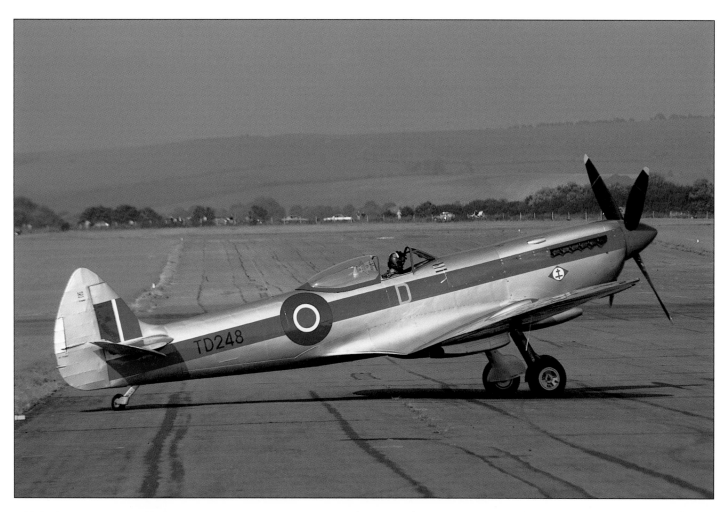

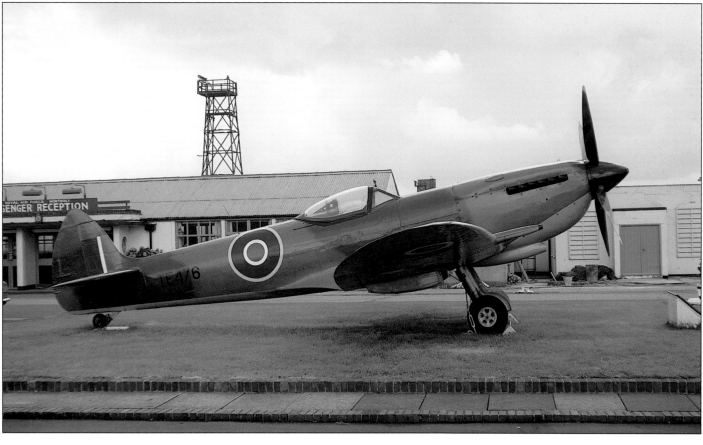

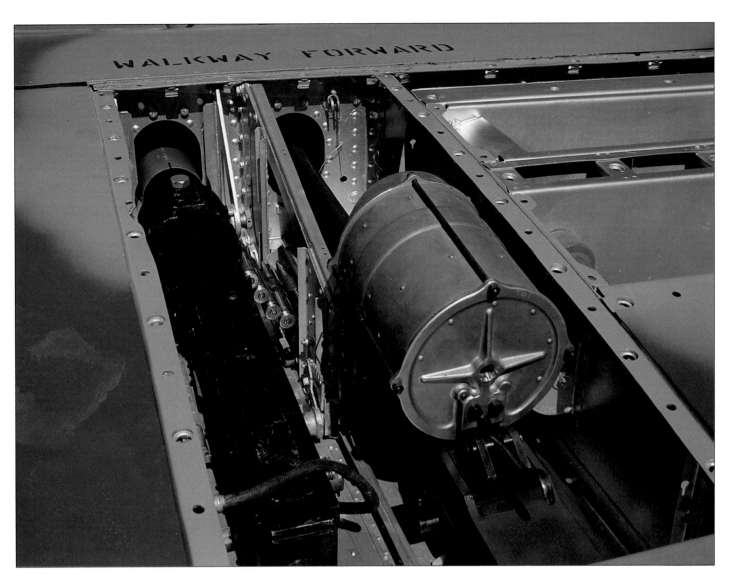

ABOVE: The gun arrangement for TE476. The 'e' wing is fitted with a .5in machine-gun nearest the fuselage and a 20mm cannon in the outer position.

OPPOSITE: TE476 has been restored back to stock condition and the cockpit looks as though it has just come off the production line.

TE476 was built at Castle Bromwich, delivered to the RAF in June 1945 and placed straight into storage with No 39 MU at RAF Colerne. In October 1949 she was transferred to No 33 MU at RAF Lyneham. In July 1951 she was allocated to her first flying unit - No 1 CAACU - at Hornchurch. Coded D, she remained there flying target duties until she retired to No 5 MU at RAF Kemble in September 1956. In January 1957 she was transferred to No 32 MU at RAF St Athan where she was prepared for participation in the Royal Tournament and allocated the Maintenance Serial 7451M. Once the Royal Tournament was over TE476 was returned to flying condition and was placed on the strength of both RAF Biggin Hill and RAF North Weald station flights from March 1958. Flying with Spitfire SL574, this pair was to become the embryo for the BBMF. From here TE476 was transferred to the station

flight at Martlesham Heath in May. She suffered a minor accident in September and was repaired a few days later prior to being issued to No 11 Group Communications Flight and was flown until struck off charge in January 1960. At the end of the month she was issued to Neatishead as a static exhibit until January 1967. She was then transferred to RAF Henlow where aircraft were being gathered for preparation prior to filming *The Battle of Britain*. Work was carried out on TE476 to enable her to taxi in the film. With filming complete she spent a short time with No 5 MU at RAF Kemble being prepared for display duty at RAF Northolt and was delivered in June 1970. Although the number was never painted on TE476, she was allocated the Maintenance Serial 8071M. In 1976 she temporarily returned to Kemble for further refurbishment.

In 1988 TE476 was one of the five Spitfire gate guardians acquired by Tim Routsis of Historic Flying and was the subject of a two and a half year restoration by Personal Plane Services at Booker for Kermit Weeks. TE476/N476TE is finished in 'stock' condition without any of the additions fitted to many recent restorations. Even the radio is the original valve type with frequency crystals.

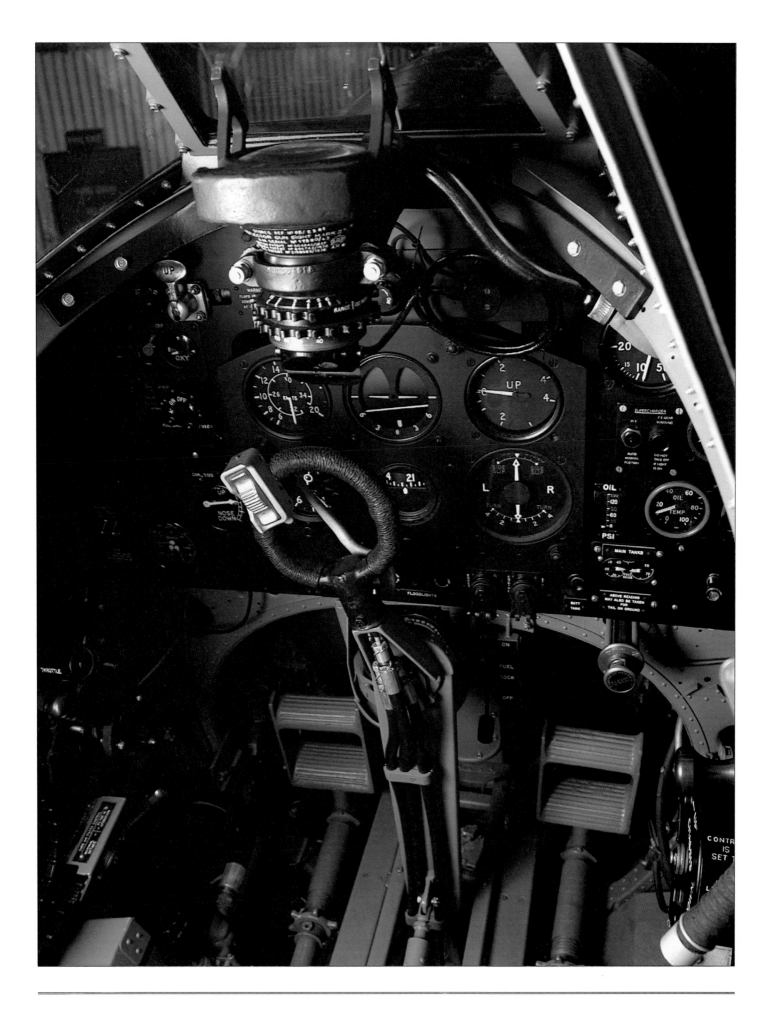

ABOVE: Tony Bianchi prepares for another test-flight. His company completed TE476's test-flying before she was shipped over to Kermit Weeks Fantasy of Flight at Polk City, Florida.

LEFT: The markings applied to TE476 are those of Sqn Ldr Raymond Lallemant, the Belgian top scoring ace with No 349 Squadron which was the second Belgian AF squadron in the RAF. The swastika visible through the perspex is from one of the exhibits that forms part of the Blue Max Museum which is run by Personal Plane Services at Booker

OPPOSITE: TE476 is rolled out after her restoration and then test-flown at Booker by PPS.

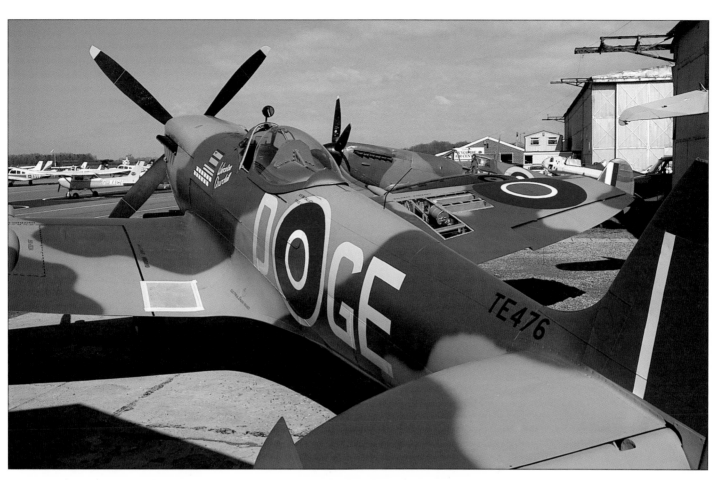

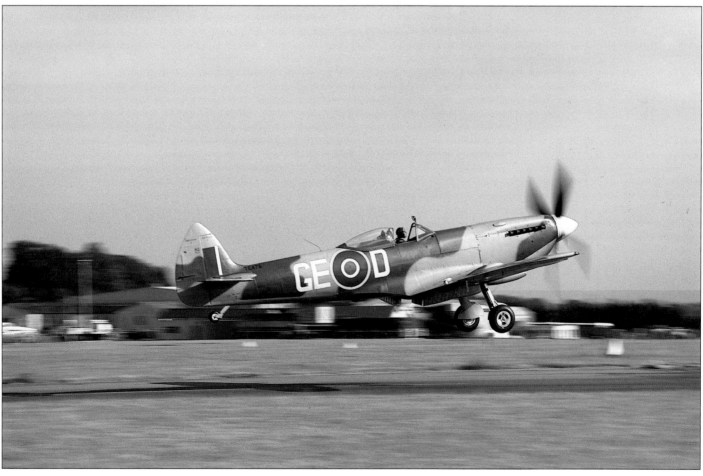

Mk XVIII

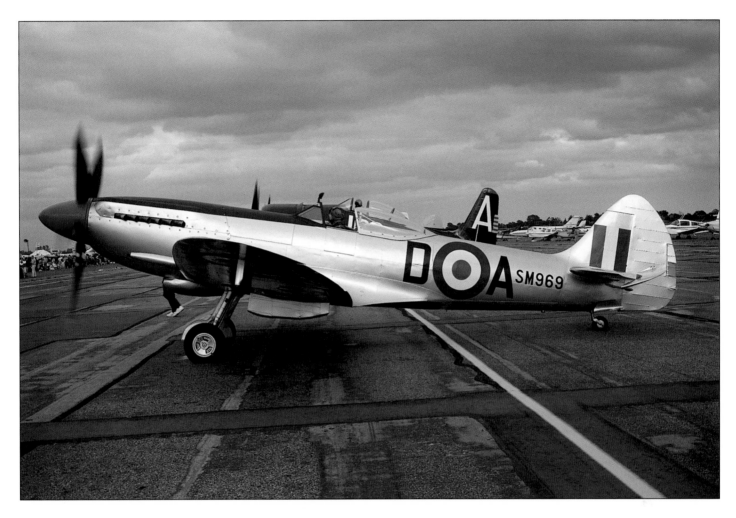

ABOVE AND OPPOSITE: SM969 was originally ordered as a Merlin-engined PR Mk XI. This contract was subsequently modified to produce 300 Mk XVIIIs of which 100 were to be the fighter variant and 200 fighter-reconnaissance. Assembled at Keevil as a Griffon-powered F Mk XVIIIe, she was delivered to No 6 MU at RAF Brize Norton during August 1945. While most of the Mk XVIIIs spent much of their early days in storage, SM969 was flown to No 76 MU at Wroughton for packing in January and onward transport to Birkenhead for shipping to Karachi. She sailed aboard SS *Sampenn* and arrived in February for delivery to ACSEA. She was listed on the India Census of May 1948 and selected for return to the UK the following month. Once in the UK, she was taken to No 47 MU at Sealand where she stayed from August 1947 at least until March 1948.

In July 1948 SM969 was sold to R & J Parkes on behalf of the Indian Government. Probably still in her original packing crate, she was shipped back out to India and was allocated the Indian AF serial HS877. None of her military service record with the Indian AF has been made available, so, apart from her retirement to New Delhi, her known history recommenced

when she was bought by Doug Arnold of the Warbirds of Great Britain and shipped back to the UK once more. Registered G-BRAF towards the end of December 1978, she was restored at the WoGB airfield at Blackbushe. Taking to the air on 12 October 1985, she was flown to Bitteswell and later kept at Biggin Hill.

The Mk XVIII was basically similar to the late production Mk XIVs. However, they were fitted with the stronger, solid spar instead of the conventional one built up from five concentric tubes as fitted to all other Spitfires. The fighter variant included an additional 31gal fuel tank in the rear fuselage while the fighter-reconnaissance variant only had one tank plus a pair of vertical cameras and one oblique

The Spitfire Mk XVIII was built too late to serve during World War 2 as the first aircraft was not delivered to No 60 Squadron until January 1947. Nos 60 and 28 Squadrons' Spitfires did see action against the guerrillas during the Malaysian emergency. In addition Nos 32 and 208 Squadrons were involved in the conflict between the Arabs and the newly formed Israel.

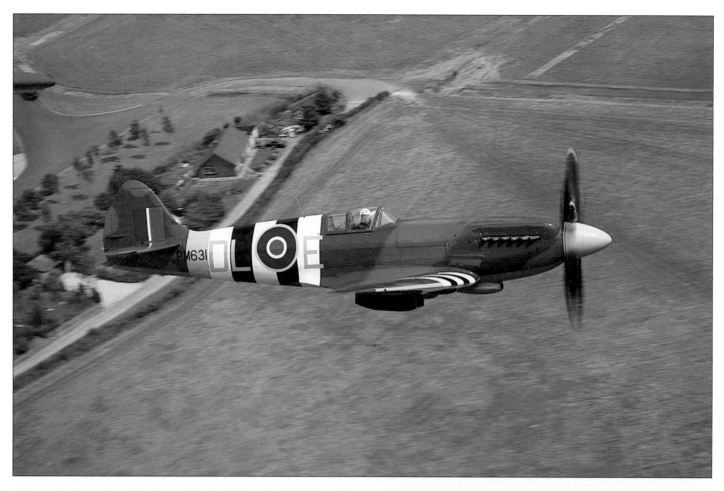

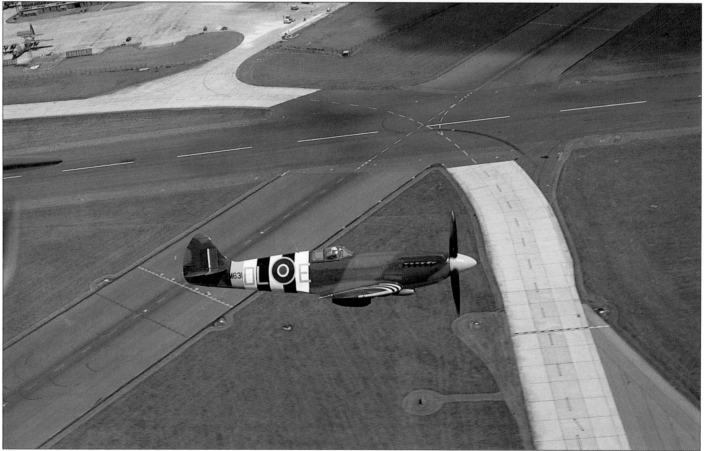

PR Mᴋ XIX

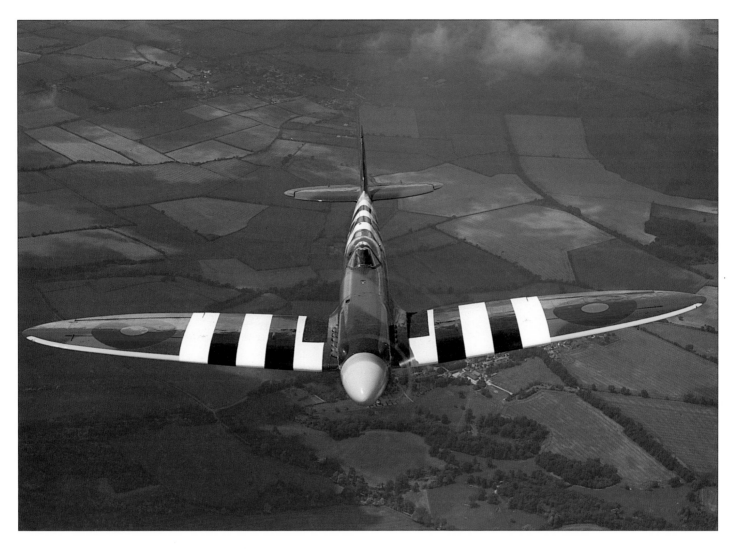

ABOVE AND OPPOSITE: PM631 is one of the BBMF's PR Mk XIXs. She is illustrated here painted in the markings of a Mk XIV of No 91 Squadron with the codes DL-E dating from around 1944 and is completed with D-Day invasion stripes. PM631 was assembled at Aldermaston in 1945 as part of a batch of 600 Mk XIs and Mk XIXs and was delivered to No 6 MU at RAF Brize Norton in November. She was issued to No 203 Advanced Flying School in May 1949. In 1950 she was modified for meteorological work and leased to Shorts for use with their Temperature and Humidity Monitoring (THUM) Flight initially at Hooton Park then moving to Woodvale. In July 1957 she was flown to RAF Biggin Hill to become part of the RAF's Historic Flight which later evolved into the BBMF.

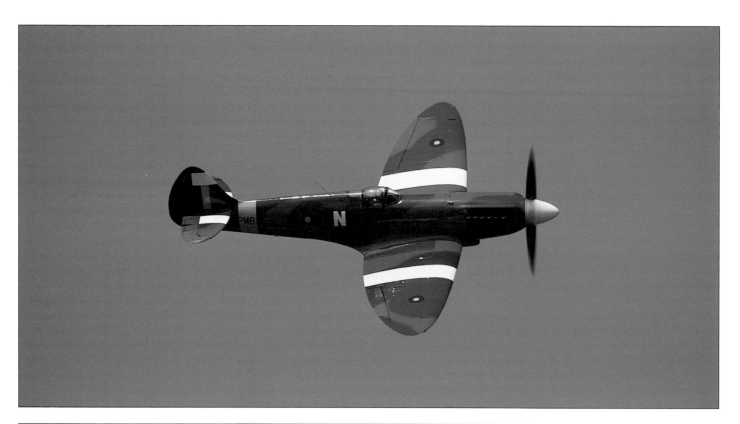

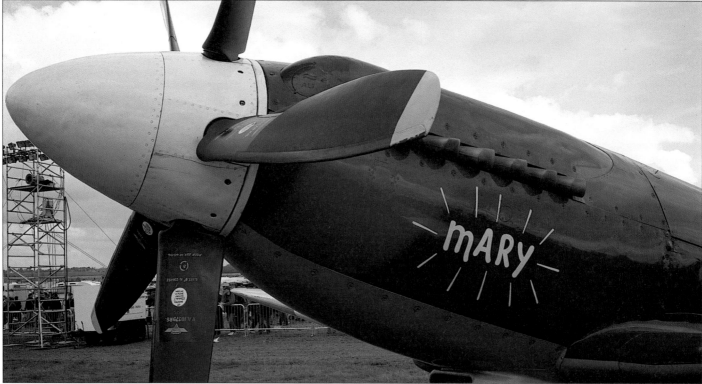

TOP AND ABOVE: PM631 had been repainted in a South East Asia Command colour scheme in which the red of the national markings is omitted. The markings are based upon that of a Mk XIV of No 11 Squadron.

OPPOSITE: The large 10ft 9in diameter propeller dominates the front of Spitfire PM631 while Hurricane PZ865 in No 261 Squadron Operation 'Hurry' markings formates behind.

PM631 is the BBMF's longest serving Spitfire having served continuously since 1957 with the exception of a trial by the Central Fighter Establishment in 1964 at RAF Binbrook. This was at the time of troubles in Indonesia and it was thought that the supersonic Lightning might be required to be deployed against the P-51D Mustang. The Lightning needed to fly dissimilar dogfights with the Spitfire to gain information on the Lightning's capabilities in this possible confrontation.

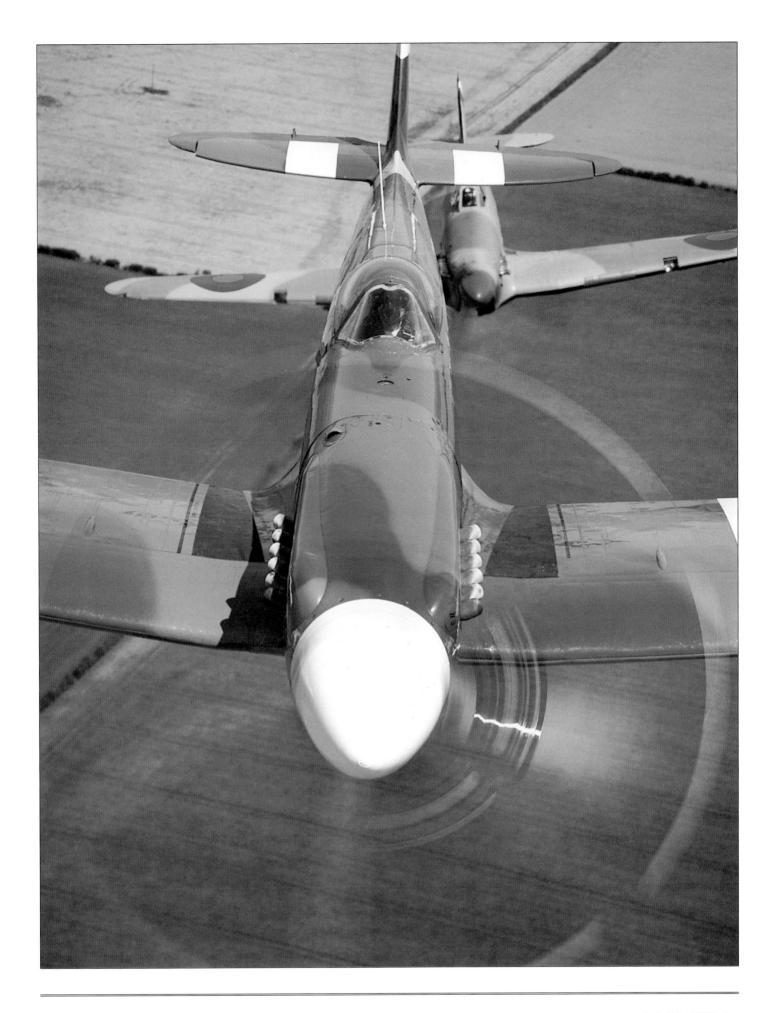

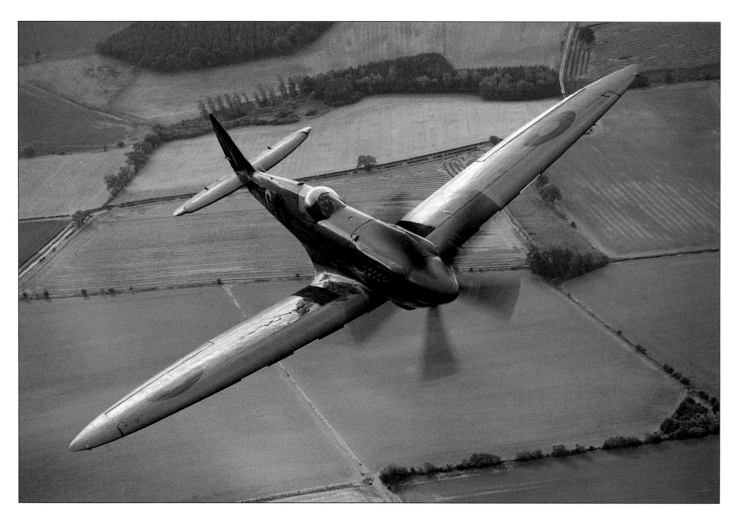

ABOVE: PS853 in the markings of No 16 Squadron, 2nd Tactical Air Force with whom she flew operationally in 1945.

OPPOSITE: PS853 displays the graceful lines of the Spitfire compared with simpler lines of the Hurricane, LF363. Sadly, LF363 suffered an engine failure and crash-landed at RAF Wittering. Fortunately, the pilot - Sqn Ldr Allan Martin - suffered minor injuries but LF363 caught fire and was thought to have been destroyed. The good news for all of us is that the skilful restoration team of Historic Flying at Audley End has been give the task of rebuilding her and she will remain the longest serving aircraft in the Royal Air Force.

PS853 was originally ordered as one of a batch of 200 Spitefuls at the Southampton works. Most of these were cancelled and PS853 was one of the 79 Spitfire PR Mk XIXs that were eventually built to this order. She was delivered to the Central Photographic Reconnaissance unit at RAF Benson in January 1945 and transferred to No 16 Squadron with No 34 Wing operating out of Melsbroek and then Eindhoven. Coded C, PS853 flew nine operational sorties in connection with Operation 'Crossbow' against the Nazi V-weapons. Subsequently transferred to No 268 Squadron which reformed as No 16 Squadron at Celle in September, she returned to the UK in the following spring and was sent to No 29 MU at High Ercall for storage in April. In January 1949 PS853 suffered a CatB flying accident and was sent to Vickers for repairs. The following February she experienced problems with her pressurisation and underwent more repairs. She was delivered to No 6 MU at RAF Brize Norton at the end of March.

Following the forming of the Short Bros & Harland Meteorological Flight, PS853 underwent conversion from the PR role to that of weather recording with No 9 MU in July and was delivered to Hooton Park on completion. In 1951 the Flight moved to Woodvale and continued on THUM sorties until June 1957 when she retired. In June 1957 the three THUM-equipped Spitfire PR XIXs were to be flown to RAF Duxford and then later to RAF Biggin Hill to join the Historic Flight. PS853 suffered a slight accident and the three left the following day in the hands of Grp Capt 'Johnnie' Johnson, who was to become one of the founder members of the BBMF. PS853 was allocated to Biggin Hill Station Flight in December, transferred to North Weald Station Flight the following March and then allocated to the Central Fighter Establishment at RAF West Raynham in April. In May she was struck off charge as Cat5c (reduce to spares) but instead she was given gate guardian duties. In 1961 she was surveyed and restored back to an airworthy state by No 19 MU and returned to RAF West Raynham in November 1962. In April 1964, seven years after the original order she was transferred to the BBMF then at RAF Coltishall.

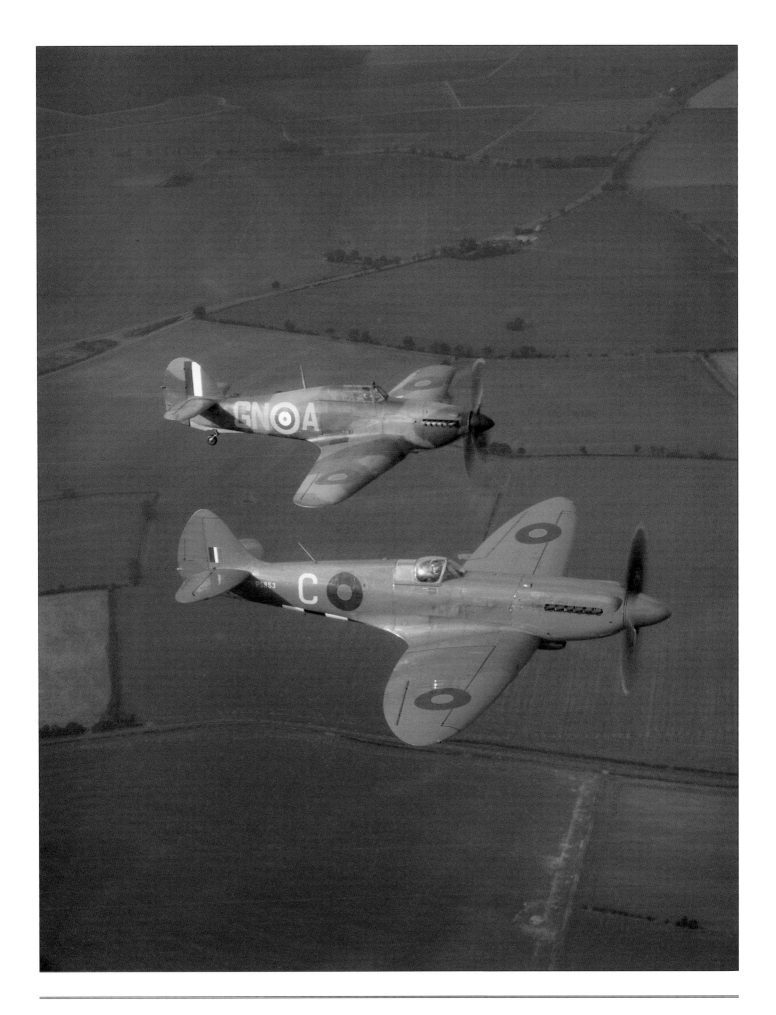

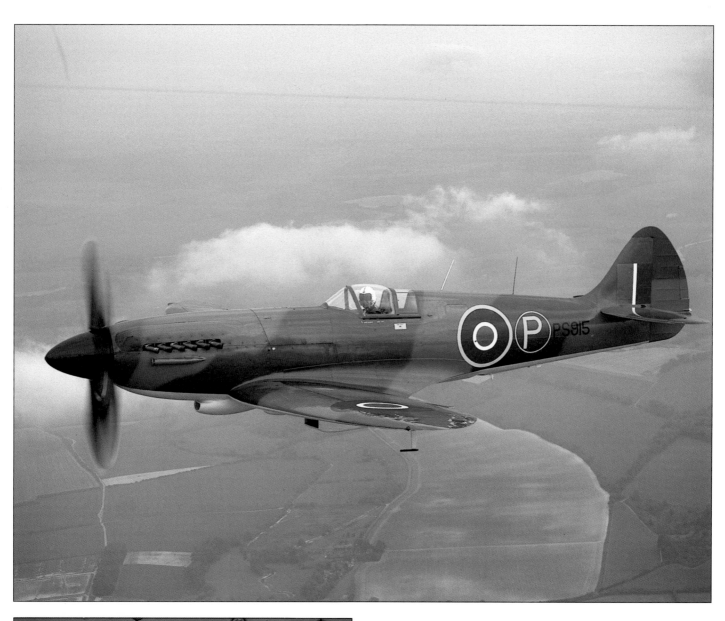

ABOVE: PS915 in Mk XIV prototype markings.

LEFT: Nose art on PS853.

OPPOSITE: In 1980 the life of PS853's Griffon 66 had expired. It was now time to apply the trial that had previously taken place with LA255 to use a Shackleton Griffon 58 to replace the Griffon 61. Several other jobs including changing her voltage from 12 to 24V made the task a lot longer that was originally planned. It was only in July 1989 that PS853 flew again, restored back into the markings she had sported as C of No 16 Squadron.

In November 1994, PS853 was offered for sale through Sotheby's and although the sale fell through another buyer was located. The well respected Harvard display pilot Euan English had become the proud owner and she was delivered to North Weald in February 1995. Sadly Euan was killed in an accident in March.

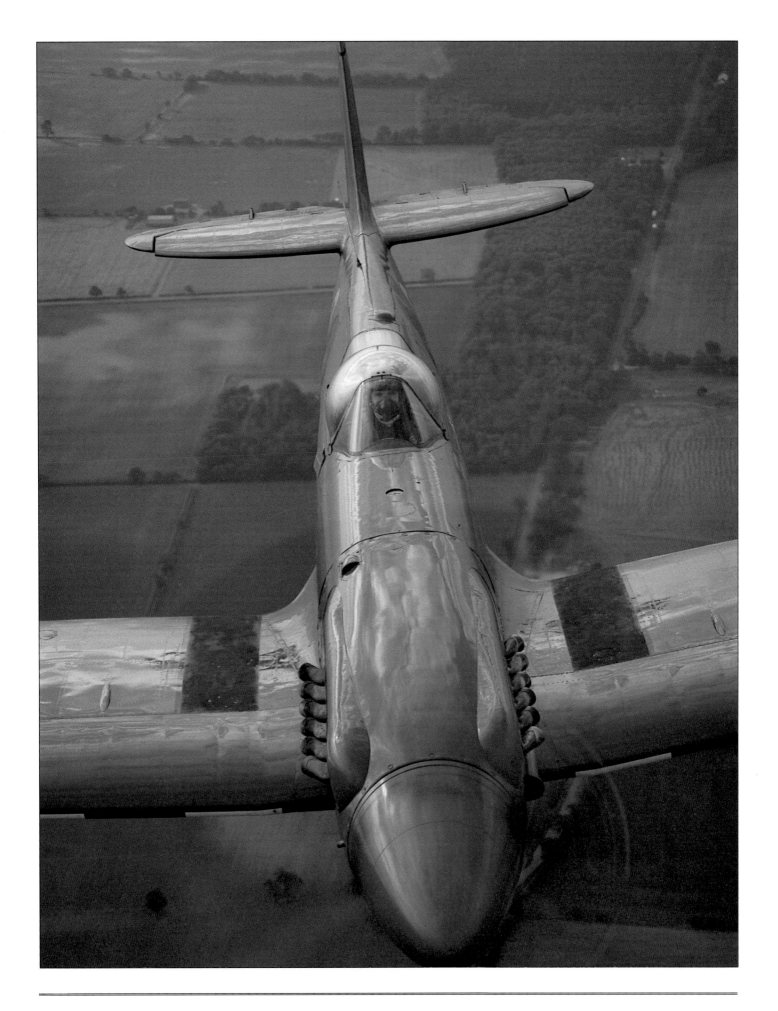

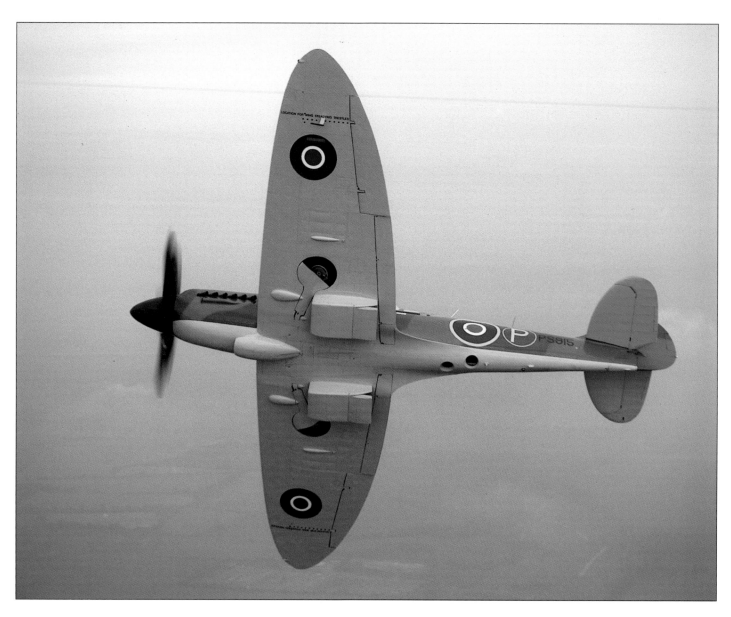

ABOVE: PS915 was painted to represent the prototype Mk XIV, JF319. The cloak has the authentic look with the large yellow P in a circle and yellow undersides indicating the aircraft as a prototype. However, in this banking shot the cunning disguise is given away by the large camera port in the belly which indicates her true identity as a PR Mk XIX.

OPPOSITE: Spot the missing items... This clean-lined fighter prototype has no guns! The PR Spitfires were normally unarmed trading the weight of the guns for speed and additional fuel space.

PS915 was another of the cancelled batch of 200 Spitefuls which was built as a PR XIX at Southampton. She was delivered to No 6 MU at RAF Brize Norton in April 1945 and then issued to RAF Benson and allocated to No 541 Squadron in June. In December 1945 she was allocated to No 1 Pilots Pool followed by the PR Development Unit in July 1946 for new camera trials, both of which were located at Benson. In

October she was allocated to No 151 RU until July 1848 when she joined No 2 Squadron. Following a couple of accidents she was repaired and transferred in June 1954 to the THUM Flight at Woodvale until she was retired in 1957.

In June 1957 PS915 was flown down to join the Historic Flight and was almost immediately retired to gate guardian duties at West Malling and RAF Leuchars. Whilst at Leuchars she was borrowed for a part in the making of *The Battle of Britain* film. Finally she moved to RAF Brawdy as a gate guardian but was borrowed for a while as part of the Griffin 57 trials. In June 1984 British Aerospace at Warton took delivery of PS915 for restoration to flying with a Griffon 57 in the hands of the apprentice training school at Samlesbury. She took to the skies again in 1987 and is shown here painted in the markings of JF319 which was the prototype Mk XIV and commemorated the work carried out by the Test Pilots of the A&AEE at Boscombe Down and at Supermarine Aviation.

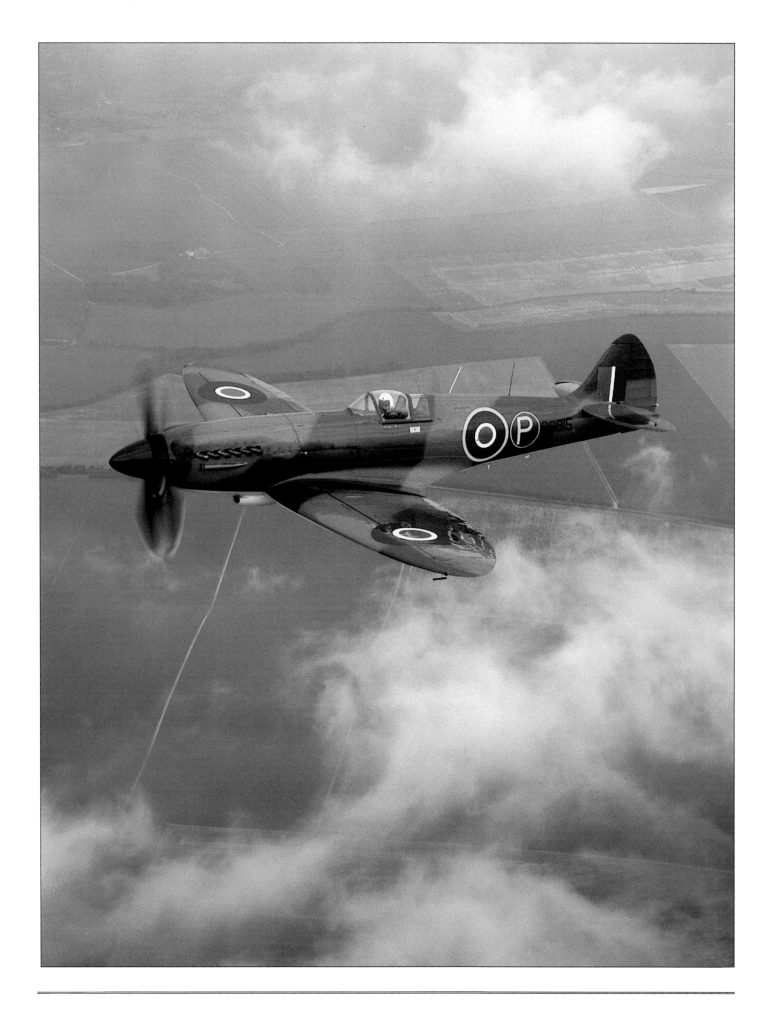

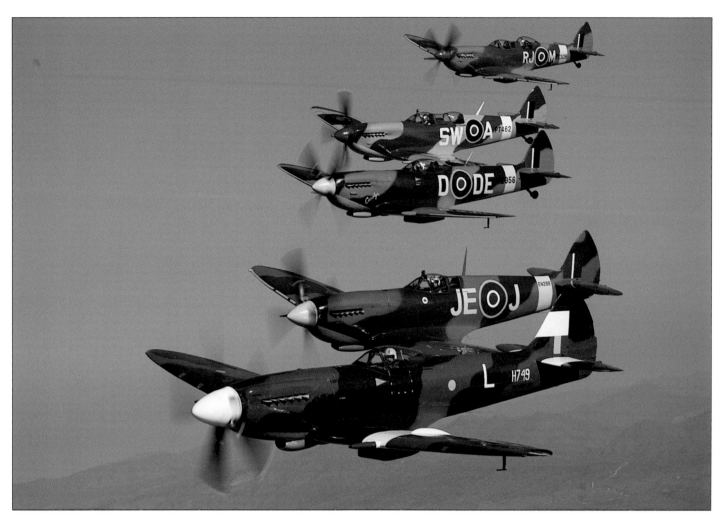

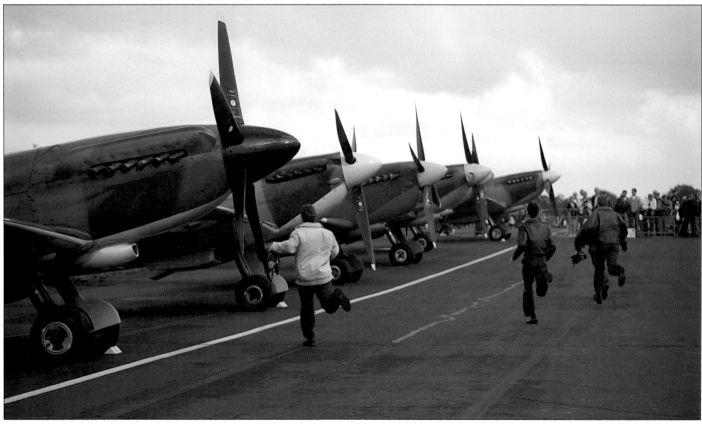

GATHERINGS

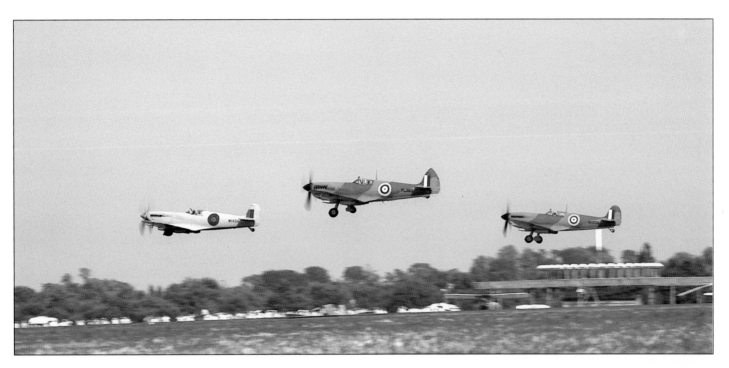

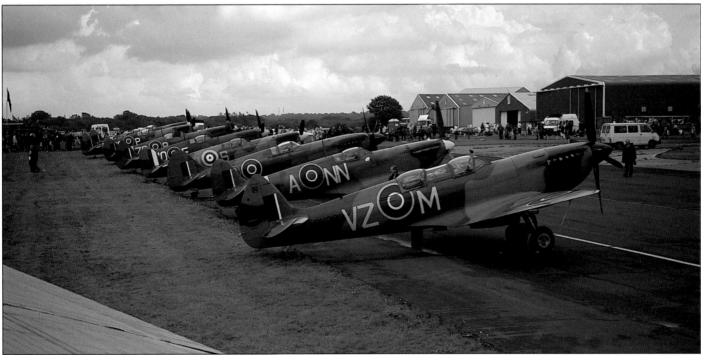

TOP: The number of airworthy Spitfires now enables organisers to arrange even more spectacular displays. Here Ray Hanna takes-off leading the Spitfire Aerobatic team at Biggin Hill.

ABOVE: This line-up of eight Spitfires is likely to be a taster of much larger Spitfire gatherings promised for the 60th Anniversary of the first flight of the prototype.

OPPOSITE TOP: A gathering of Spitfires over the Arizona mountains, near to Phoenix.

OPPOSITE BOTTOM: Air Training Corps Cadets sprint to their aircraft in a rerun of the scramble by young pilots that was so familiar at Biggin Hill during World War 2.

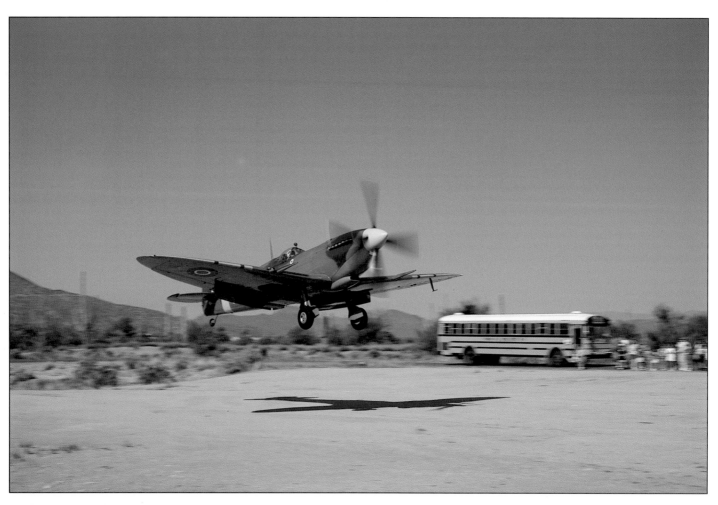

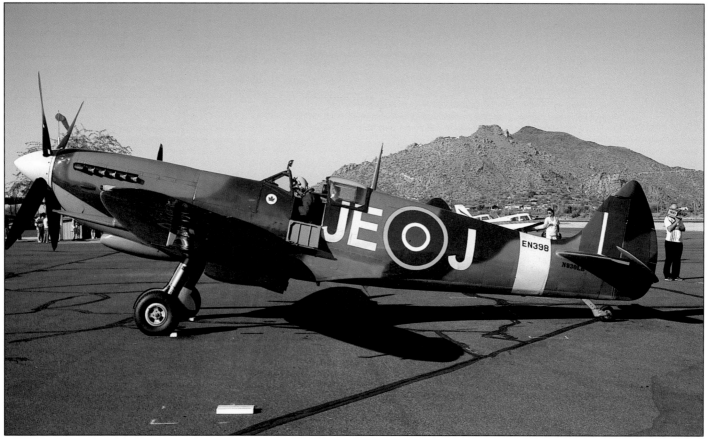

EAGLE SQUADRON

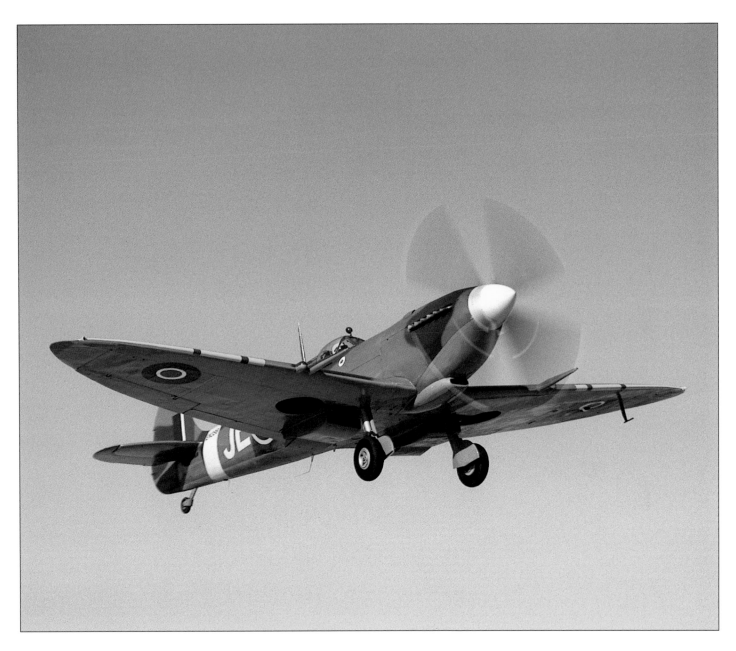

Great Britain declared war on Nazi Germany on 3 September 1939 . The United States remained neutral but was quietly supplying the Allies and especially Great Britain with vital armaments. It was not until the Japanese attack on Pearl Harbor in 1941 that the US entered into the war

For a few individuals this had not been quick enough. These men were unable to stand on the sidelines. Attempts were made by the FBI and US Government to stop them as their volunteering services to a country at war compromised the US neutrality laws. One penalty for their actions could have been loss of their US citizenship but this did not stop a substantial number making the journey to England. Soon there were sufficient American pilots to form what were to be known as the Eagle Squadrons. Three Spitfire squadrons were formed - Nos 71,

121 and 133 . In 1941 when the USA joined with the Allies against the Axis forces, the Eagle Squadrons reluctantly transferred to the USAAF 8th Air Force. However, they were allowed to keep their RAF Wings and decorations. These pilots were to become heros to many but by the time the war was over one in three of them had been killed.

ABOVE AND OPPOSITE TOP: Spitfire MA793/N930LD 'EN398' arrives at Carefree Airport in the hands of Bill Destifani.

OPPOSITE BOTTOM: MA793 is painted as 'EN398' coded JE-J representing the steed of 38-victory ace 'Johnnie' Johnson.

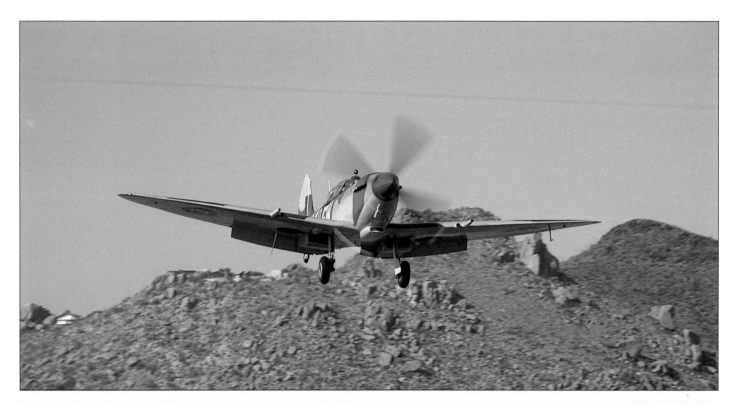

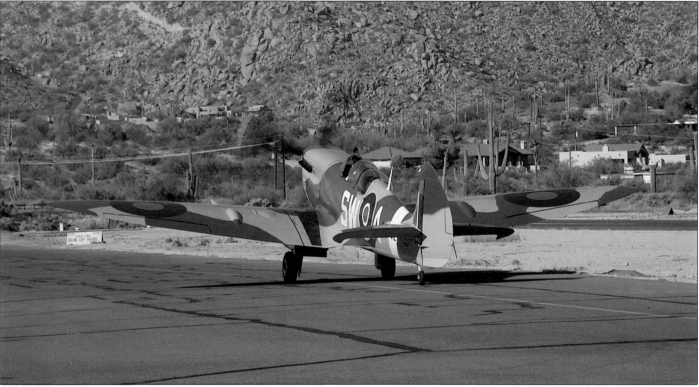

TOP, ABOVE AND OPPOSITE : A series of views of Spitfire T9 PT462 arriving and parked at Carefree Airport prior to the air-show at nearby Scottsdale.

PT462 was built as an HF Mk IX at Castle Bromwich and delivered to No 39 MU in July 1944. Later that month she was moved to No 215 MU for packing and shipping to the Mediterranean Allied Air Force, arriving during August. She has no known RAF service apart from that with No 253 Squadron as SW-A in April 1945. Later PT462 was to serve with the Italian AF as MM4100 and in 1952 was sold to the Israeli AF as 0607, changing to 2067 on arrival in Israel. The almost buried remains of 2067 were located in a kibbutz, bought by Robs Lamplough and shipped to the UK in May 1983. Sold in April 1985 to the late Charles Church and registered G-CTIX, PT462 was restored as a two-seat T9 trainer by Dick Melton and returned to the air on 25 July 1987. Sold following the death of Charles Church, she is currently Florida-based with Bill Goldstein as N462JC.

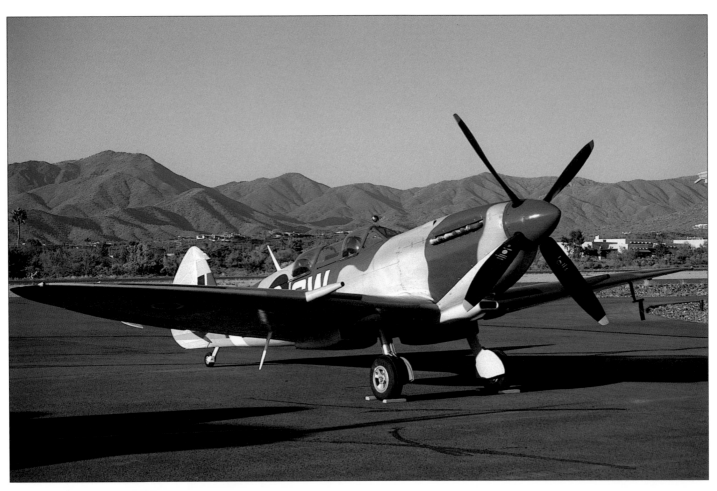

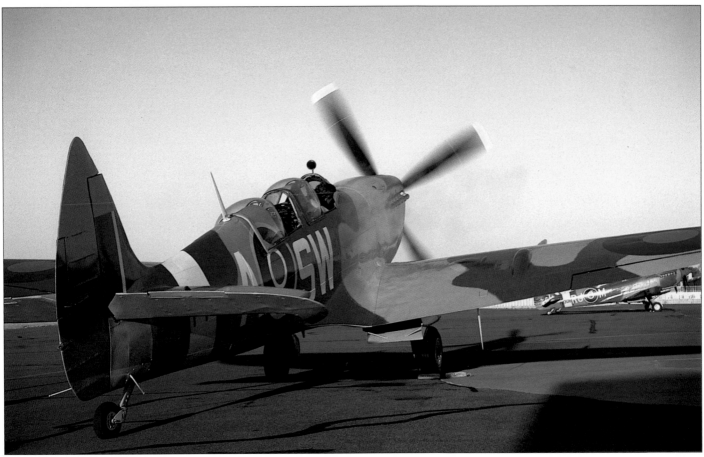

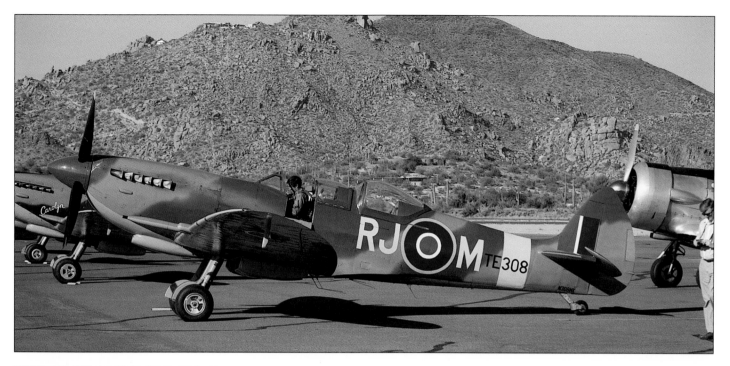

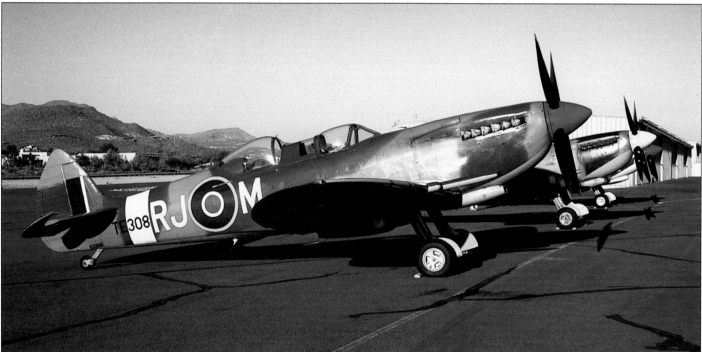

TOP AND ABOVE: Bill Greenwood's T9 TE308/N308WK at Carefree. Castle Bromwich-built HF Mk IXe TE308 was delivered into store with No 39 MU in June 1945, then No 29 MU in January 1950, before being sold to Vickers in July for conversion to Irish Air Corps T9 IAC163. Sold in March 1968 as G-AWGB, she was leased to *The Battle of Britain* film makers as a camera ship. Passing hands several times, she had her rear cockpit stripped and fared over. Sold again to Woodson K Woods as N92477, she was restored back to a T9 as N308WK. In 1983 TE308 was sold to Bill Greenwood of Aspen Colorado.

OPPOSITE: David Price's NH749/NX749DP at Carefree. Assembled at Aldermaston, FR Mk XIV NH749 was delivered to No 33 MU in February 1945. Packed by No 215 MU for shipping to Karachi, she arrived in July and was listed on the ACSEA and India Census prior to sale to the Indian AF. With no known service details, the remains of NH749 were purchased by Ormond Haydon-Baillie in 1977. Sold to A & K Wickendon for an extensive rebuild by Craig Charleston, NH749 was sold again in 1985 to David Price and NH749/NX749DP is currently located with the Santa Monica Museum of Flight in California.

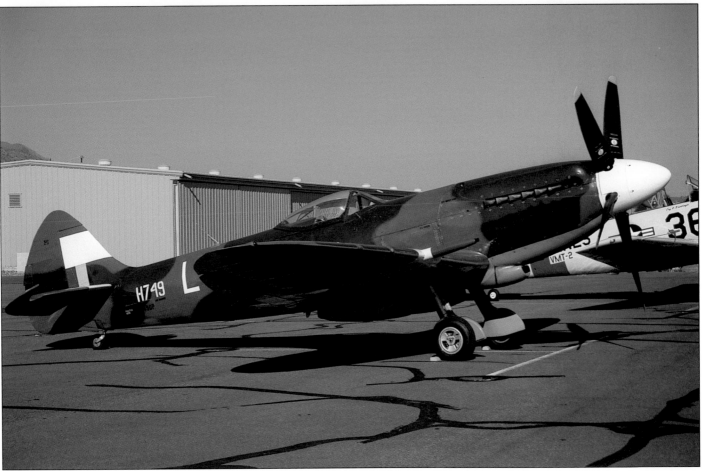

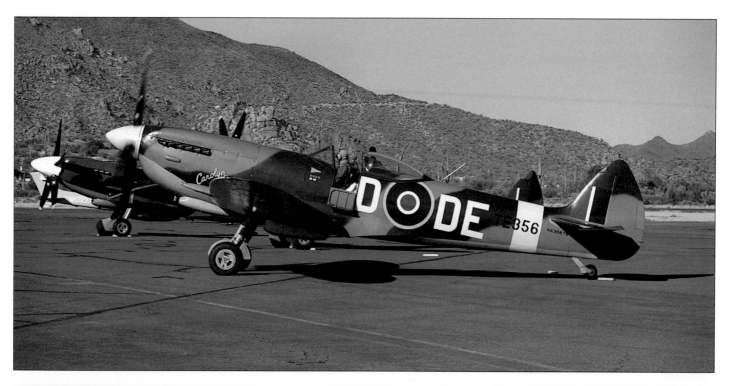

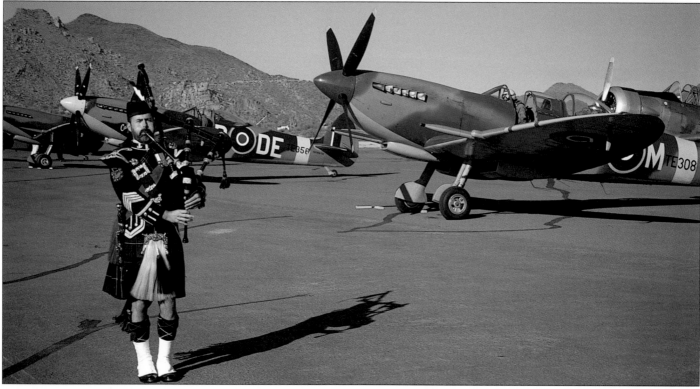

TOP: Mike Searle taxies in TE356/NX356TE at Carefree. Castle Bromwich-built TE356 was delivered to the RAF in June 1945 and allocated to No 695 Squadron with codes 4M-M (later 8Q-Z); she was still flown when the squadron was renumbered No 34. With No 2 CAACU from August 1951 until September 1952 and an instructional airframe (6709M and 7001M) at RAF Bicester, she was loaned to *The Battle of Britain* film makers in 1967 before joining CFS No 4 Squadron at RAF Kemble. Restoration commenced but was halted and TE356 was placed on a pole by the CFS HQ at RAF

Little Rissington in December 1970. In April 1976 she moved to RAFC Cranwell and RAF Leeming during 1978. In 1986 Doug Arnold acquired her. In 1990, the restored TE356 was purchased by Evergreen Ventures of Marana, Arizona

ABOVE: A Scottish piper welcomes the Spitfires to Carefree.

OPPOSITE TOP: A Spitfire line up at Carefree.

OPPOSITE BOTTOM: Bill Destifani starts up EN398.

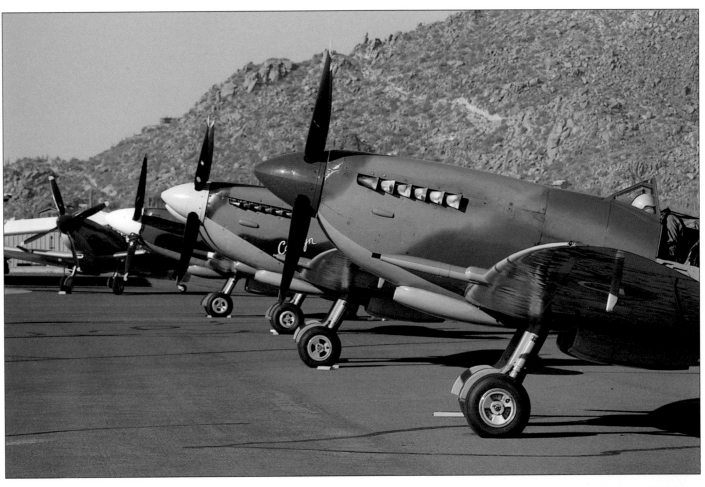

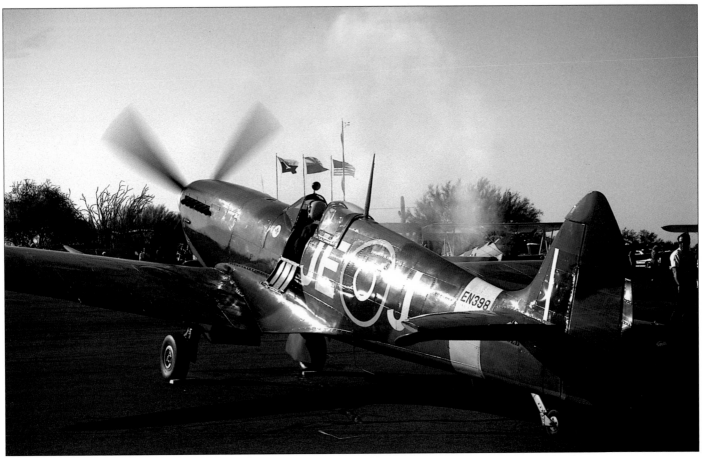

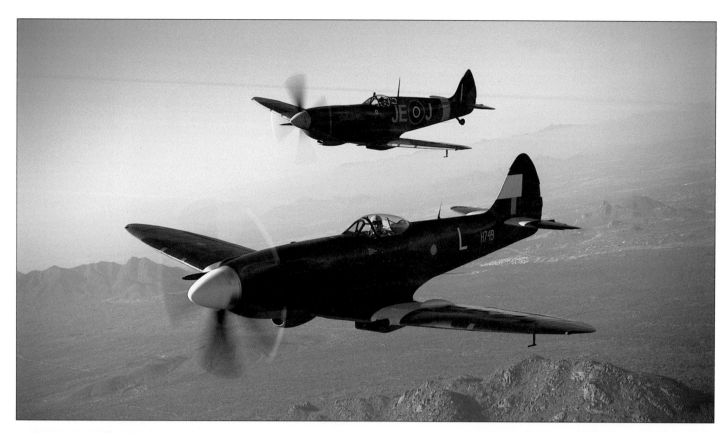

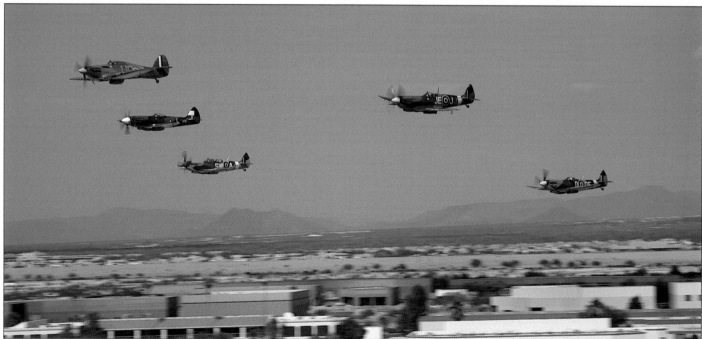

TOP: A comparison between the sleeker, longer-nosed Spitfire FR Mk XIV - NH749 powered by the Griffon - and the earlier Rolls-Royce Merlin-powered Mk IX, MA793 'EN938'. Although the later mark was some 1,000lb heavier than the earlier variant, the new engine gave it in the region of 25-35mph extra speed and a better climb performance.

ABOVE: Davis Price's Hurricane IIb, P2970/N678DP, leads four of the Spitfires in formation over Scottsdale.

OPPOSITE: Formation of six Spitfires over the spectacular barren Arizona mountains near to Phoenix. This formation is led by Bruce Lockwood in David Price's NH749/NX749DP followed by Chris Woods, who organised the Spitfire gathering, flying in David Prices's MA793/N930LB 'EN938'. Next is Evergreen Ventures' LF Mk XVIe, TE356, in the hands of Pat McGarrie. Outside him is Elliott Cross in PT462 and Charlie Brown in RW382.

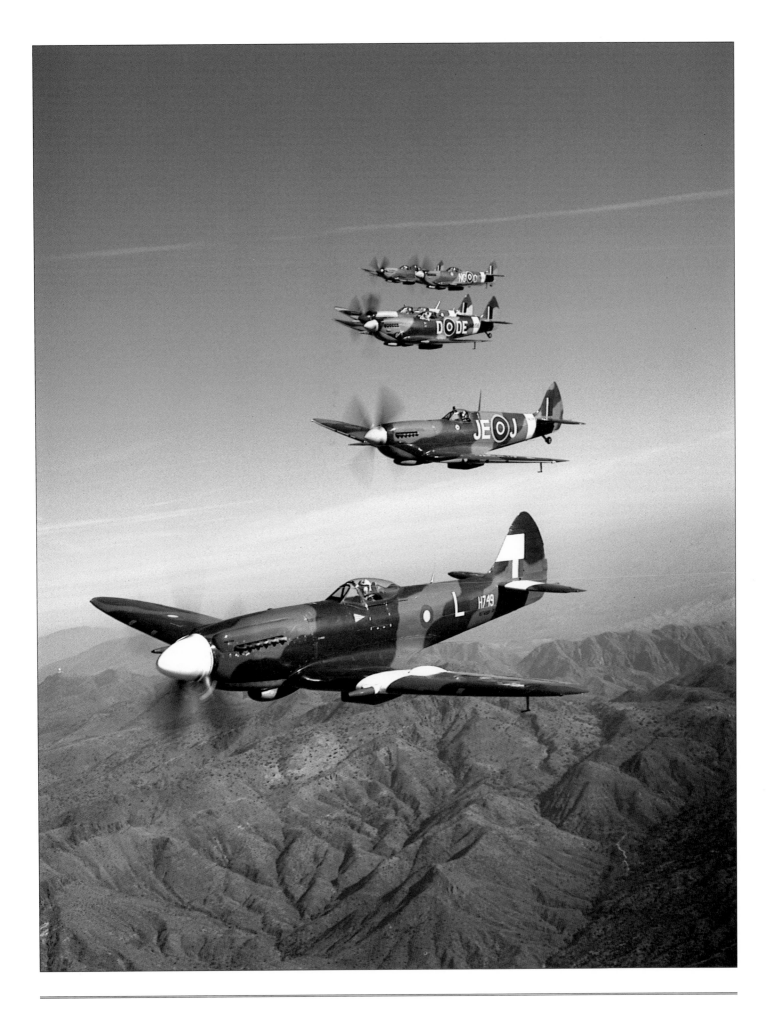

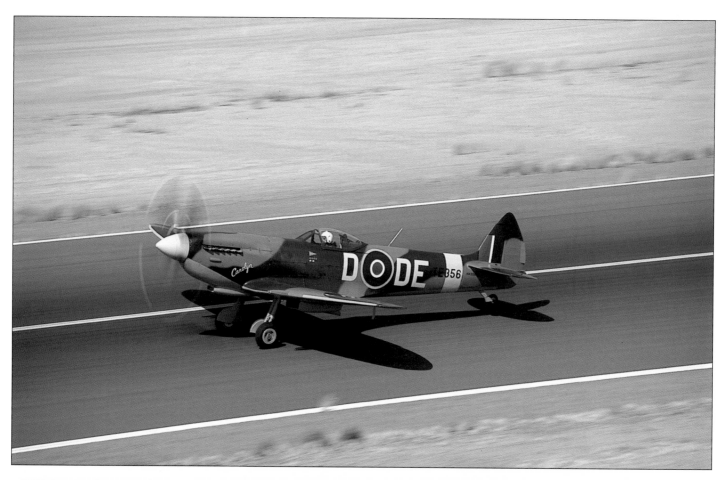

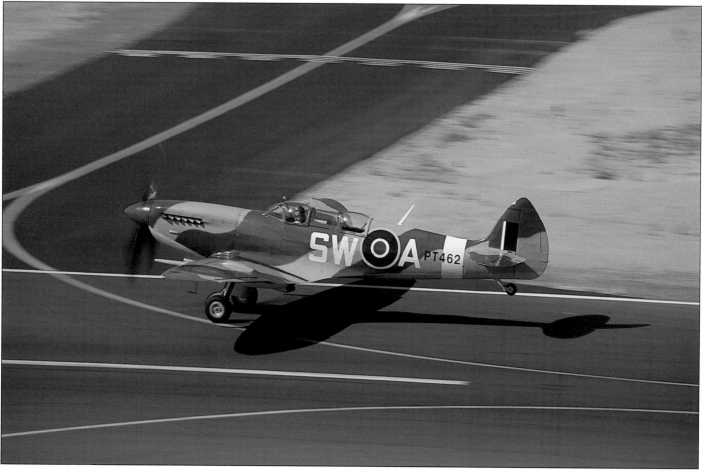

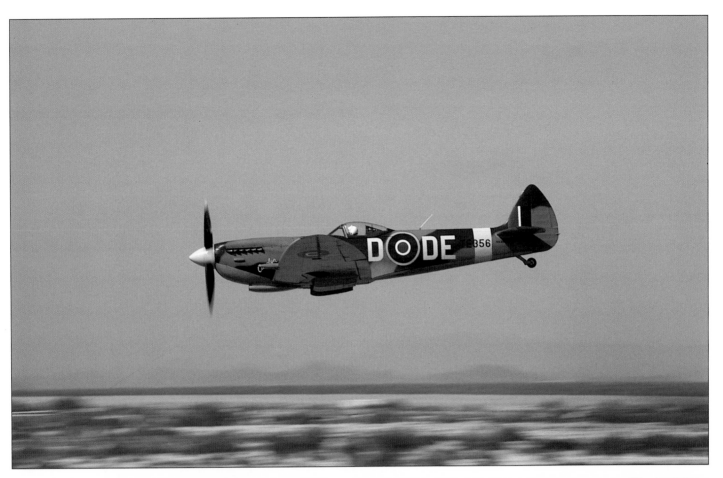

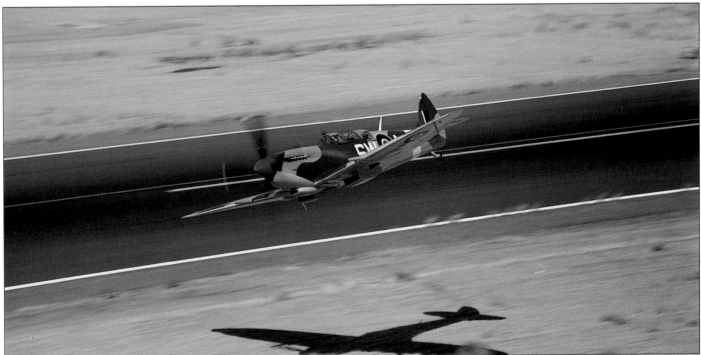

TOP: TE356, the LF Mk XVIe ex-RAF Bicester parade square, RAF Little Rissington and RAF Leeming gate guardian, makes another flypast for the crowds at Scottsdale.

ABOVE: Finished in April 1945 markings - SW-A of No 253 Squadron - Elliott Cross makes a low pass in PT462.

OPPOSITE TOP: TE356 returns to Scottsdale after a thrilling formation display.

OPPOSITE BOTTOM: PT462 lands to conclude the display.

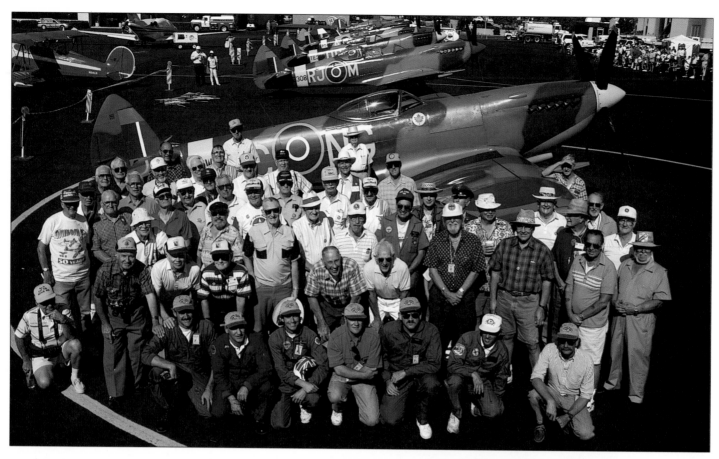

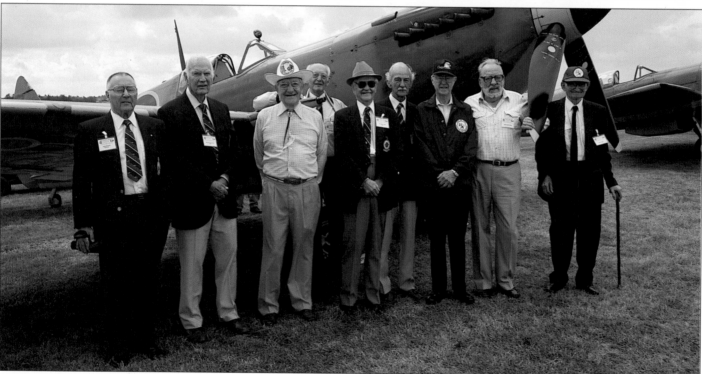

TOP: World War 2 veterans get together for the Spitfire gathering at Scottsdale: this group includes seven from the Eagle Squadrons. The front row includes the current owners/pilots of these Spitfires.

ABOVE: The Flying Legends display at Duxford in the UK had its own gathering of the Eagle pilots to commemorate the 50th anniversary of the ending of World War 2.

OPPOSITE: The line-up of Spitfires and a Hurricane at Scottsdale with new US addition RW382 in the foreground.

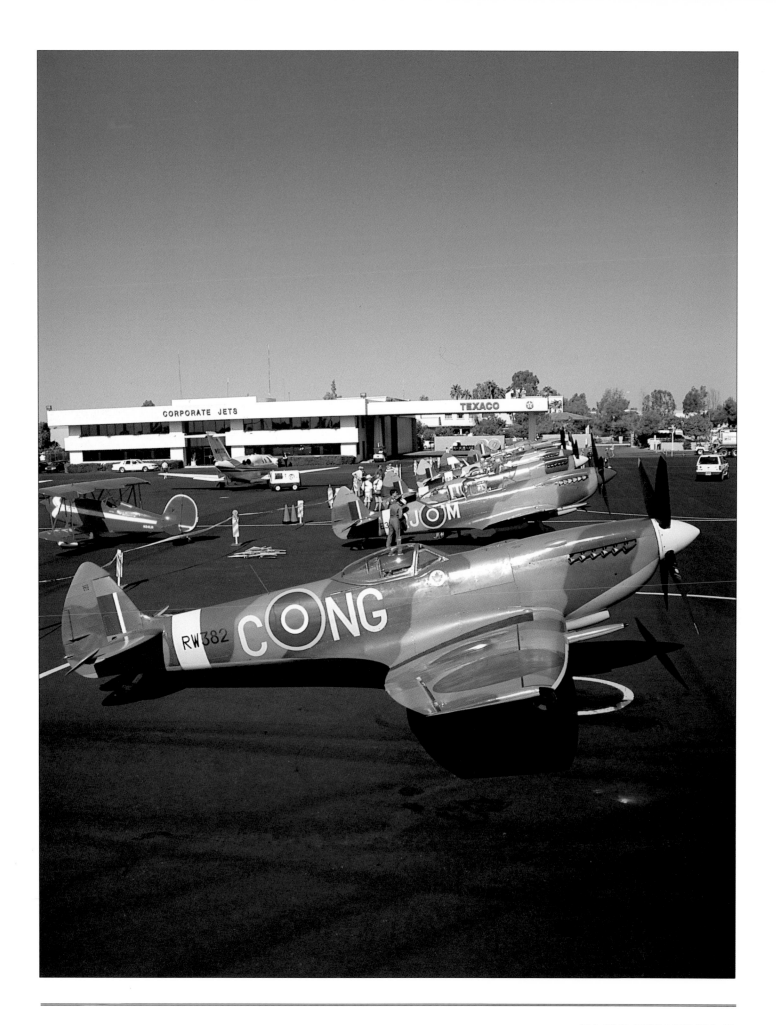

USEFUL ADDRESSES

If you wish to see the aircraft illustrated in this series of books, the list below details most of the aircraft operators and airshow organisers who may be able to assist.

<u>UK</u>
Air Displays International
Biggin Hill Airport
Biggin Hill
Westerham
TN16 3BN

Tel: 01959 572277
Fax: 01959 575969
Airshow

B-17 Preservation Ltd
PO Box 132
Crawley
W Sussex
RH10 3YB

Tel: 01293 883213
Operator and Airshow

Battle of Britain Memorial Flight
Royal Ait Force
Coningsby
Lincs
LN4 4SY

Tel: 01526 342581/343414
Fax: 01526 343414
Operator and Museum

Blue Max Movie Aircraft Colllection
Wycombe Park Booker
Nr Marlow
Bucks
SL7 3DP

Tel: 01494 529432
Fax: 01494 461236
Airshow, Museum and Operator

Fighter Meet Ltd
2 Field End Road
Pinner
Middx
HA5 2QL

Tel: 0181 866 9993
Fax: 0181 868 0258
Airshow 2nd week May

Imperial War Museum
Duxford Airfield
Duxford
Cambs
CB2 4QR

Tel: 01223835000 x 212
Fax: 01223 834 117
Airshows and Museums

Old Flying Machine Company
Duxford Airfield
Duxford
Cambs
CB2 4QR

Tel: 01223 836705
Fax: 01223 834117
Airshow and Operator

Royal Navy Historic Flight
Royal Naval Air Station
Yeovilton
Somerset
BA22 8HT

Tel: 01935 456279
Fax: 01935 455273
Operation plus airshow organised by Royal Navy

Shuttleworth Collection
Old Warden Airfield
Biggleswade
Beds
SG18 9EP

Tel: 0891 323310
Fax: 01767 627745
*Airshows on 2nd week of month (May-Oct),
Museum and Operator*

The Fighter Collection
Duxford Airfield
Duxford
Cambs
CB2 4QR

Tel: 01223 834973
Fax: 01223 836956
Airshow and Operator

Swordfish Heritage Trust
Royal Naval Air Station
Yeovilton
Somerset
BA22 8HL
Tel: 01935 455382
Operator plus airshow organised by Royal Navy

<u>USA</u>
Cavanaugh Flight Museum
4572 Claire Chennault
Addison Airport
Dallas
Texas 75248
USA

Tel: 00 1 214 931 2214
Fax: 00 1 214 248 0907
Museum

Confederate Air Force HQ
Midland International Airport
PO Box 62000
Midland
Texas 79711-2000
USA

Tel: 00 1 915 563 1000
Fax: 001 915 563 8046
Airshow, Museum and Operator

Experimental Aircraft Association
PO Box 3086
Oshkosh
Winconsin 54903
USA

Tel: 00 1 414 426 4800
Museum and Airshow

Planes of Fame Museum
14771 Pioneer Trail
Eden Prarie
Minnesota 55347
USA

Tel: 00 1 612 941 7820
Fax: 00 1 612 941 0944
Museum and Operator

Santa Monica Museum of Flight
2772 Donald Douglas Loop North
Santa Monica
California 90405
USA

Tel: 00 1 310 392 8822
Fax: 00 1 310 450 6956
Museum and Operator